IMAGES
of America

BUFFALO'S
WATERFRONT

IMAGES
of America

BUFFALO'S
WATERFRONT

Thomas E. Leary and Elizabeth C. Sholes

ARCADIA
PUBLISHING

Published by Arcadia Publishing
Charleston SC, Chicago IL, Portsmouth NH, San Francisco CA

Printed in the United States of America

Library of Congress Catalog Card Number: 2008922962

For all general information contact Arcadia Publishing at:
Telephone 843-853-2070
Fax 843-853-0044
E-mail sales@arcadiapublishing.com
For customer service and orders:
Toll-Free 1-888-313-2665

Visit us on the Internet at www.arcadiapublishing.com

Contents

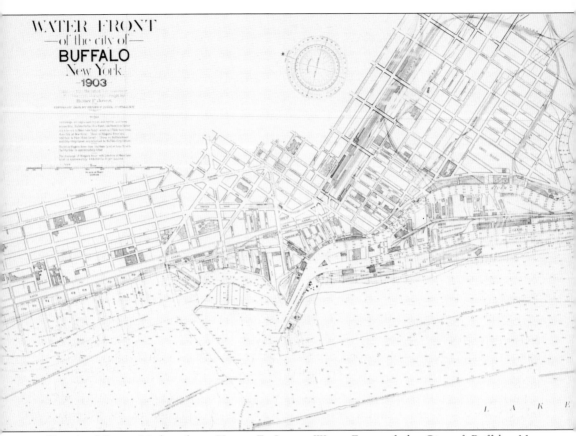

Detail of Inner Harbor from Henry E. Jones, *Water Front of the City of Buffalo, New York* (1903).

Introduction

Buffalo was once a great port. This book provides an introduction to the history of the harbor during the high tide of its prosperity between the 1850s and the 1950s. The images reproduced represent a sampling from the rich resources of the Buffalo & Erie County Historical Society (BECHS), which has been acquiring materials about the Great Lakes since its founding in 1862.

Inhabitants of Buffalo have often felt that the city's location created its destiny. Two great inland waterway systems drain the heart of the North American continent: the Mississippi with its tributaries and the chain of the Great Lakes leading down to the St. Lawrence River. Because Niagara Falls formed a formidable barrier to continuous navigation on the Great Lakes-St. Lawrence route to the sea, travelers and merchants sought passages that by-passed the cataracts.

Buffalo's establishment as the western terminus of the Erie Canal in 1825 converted its tiny waterfront into a gateway to the Midwest and a backdoor to the Atlantic. The city flourished as a natural transfer point for marine traffic moving between the East Coast and the four Great Lakes above Niagara Falls. The growth of the harbor depended upon the strategic intersection of the Erie Canal with Lake Erie and the Niagara River. After 1836, railroads were added to the transportation mix where land and water met. Over the next century of port development the railroads exercised enormous influence.

Where water and rail converged the port of Buffalo accumulated an extensive inventory of structures and equipment for handling and storing bulk commodities such as east-bound grain and iron ore or westbound coal. An Inner and Outer Harbor system, embracing both docks on the Buffalo River and anchorages in Lake Erie, developed around the proliferation of artificial slips, basins, and coastal protection works.

As the industrialization of the shoreline proceeded, grain elevators, which had been invented here in 1842, eventually dominated the waterfront visually and economically. Indeed, around the time of the Civil War, visiting novelist Anthony Trollope pronounced that "over and above the elevators there is nothing especially worthy of remark at Buffalo." Local boosters later proclaimed, "Here is Buffalo's pre-eminence; it is the greatest port of the world for the transfer of grain from boat to shore."

During the early twentieth century manufacturing augmented commerce. Flour and animal feed mills now processed waterborne grain while steel plants smelted and refined iron ore. Some harborside cargo handling operations were mechanized extensively; others remained dependent

on manual labor. The regional waterfront extending from the Tonawandas south through Buffalo to Lackawanna included many kinds of daily activities and moments for contemplation.

Images taken by amateur and professional photographers in this volume reveal facets of places, occupations, and pastimes that no longer exist. To illustrate the variety of life along the water we selected photographs from several BECHS collections, including the General, Nagle, Harbors & Waterways, Lake Marine, Porterfield, and Fitzgerald, as well as albums and scrapbooks. There are views of cargo docks and shipyards, whaleback steamers and busy tugs, major construction projects, canal shanties and their inhabitants, and tranquil summer days of recreation on the waterways.

The reasons behind Buffalo's dwindling stature as a port are complex and involve the development of alternative trade routes—including the improved Mississippi and St. Lawrence Rivers—along with shrinkage of the local industrial base. The merits of assorted plans to redevelop the waterfront for recreational and residential purposes likewise lie beyond the scope of this book. However, other communities have incorporated the glory of their heritage into their visions for the future. With its distinguished history, Buffalo should do no less.

Thomas E. Leary
Elizabeth C. Sholes
May 1997

One

Growth of the Harbor

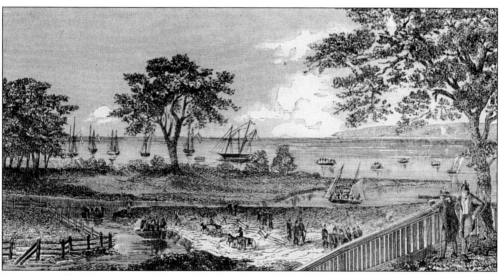

The port of Buffalo began at the mouth of a sluggish creek. This engraving of military activity during the War of 1812 depicts at lower left the intersection of Little Buffalo Creek with Buffalo Creek, which then emptied into Lake Erie on the lower right. When the Erie Canal opened in 1825 with Buffalo as its western terminus, traffic flowed along this route. Travelers and cargoes transferred here between canal boats and lake ships.

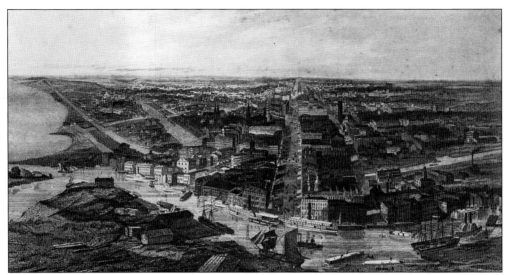

Commercial development of the Inner Harbor required the removal of obstructions for navigation and expansion of dock space. This 1853 engraving provides a bird's-eye view of sailing vessels, steamboats, and canal barges on the Buffalo River (bottom). The Erie Canal (left) curves toward Main Street and extends east as the Main & Hamburg Canal (right). Smaller artificial waterways connect the traffic moving between Lake Erie and the canal.

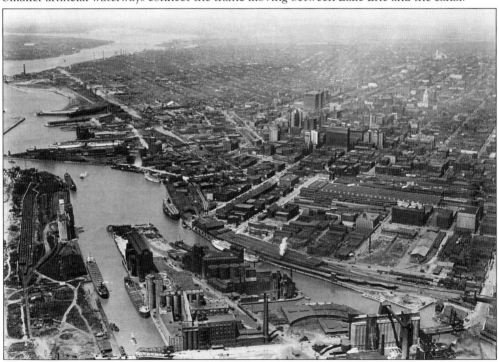

This 1924 aerial photograph shows downtown's proximity to a network of waterways and railways. Many older slips have been filled in. The principal Inner Harbor docks lie along the Buffalo River and City Ship Canal (bottom). Erie Basin (left) contains the western terminal for the newly-completed Barge Canal; the former Erie Canal route remains visible (left center). The Niagara River divides Fort Erie, Ontario, from Buffalo's West Side (top).

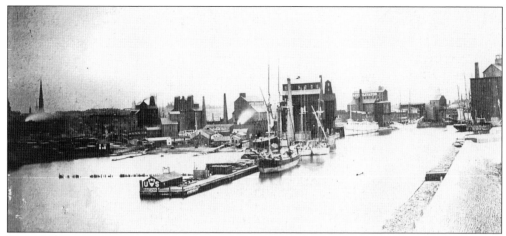

During the 1870s mariners entering the Buffalo Harbor found a skyline of church steeples and grain elevators. Samuel Wilkeson's harbor improvement projects in 1819–1820 had made the mouth of the river navigable. However, powerful railroads controlled much of Buffalo's waterfront. The Delaware, Lackawanna & Western Railroad even appropriated the U.S. Government's North Pier (center) as the site for their own coal trestle.

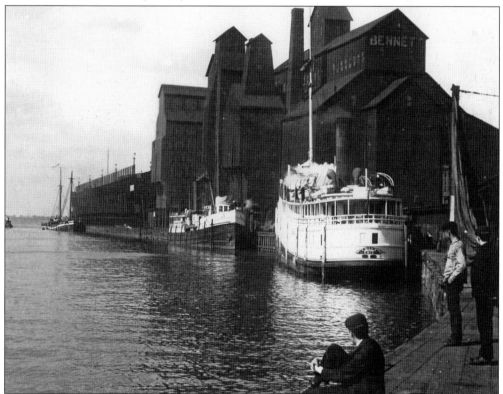

Waterfront spectators gazing down the Buffalo River toward its mouth during the early twentieth century saw a great variety of structures and activities along the water. Past the Anchor Line dock stood the Bennett and Union Grain Elevators, and beyond them the DL & W coal trestle. Also present (right) is the *China*, one of the many famous lake vessels that called at the Port of Buffalo over the years.

11

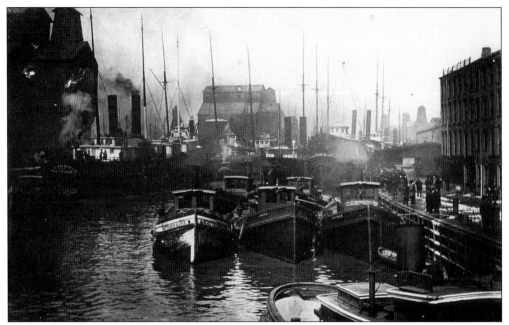

Recalling the waterfront of the 1830s, local raconteur Samuel Welch wrote, "[the ships] gathered in such numbers in the creek that you could pass from one to another across the creek . . ." With tugs clustered along Front Street Dock between Main and Washington Streets and steamships clogging the river, this 1890s view indicates that subsequent Inner Harbor improvements had not alleviated the congestion chronicled by Welch.

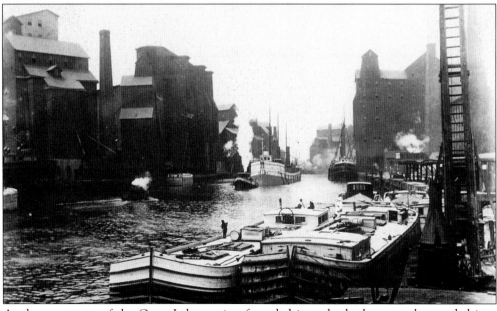

As the commerce of the Great Lakes region funneled into the harbor, vessels crowded into spots where water met the land. Many craft carried people who both lived and worked on the waterways. The outboard canal boat, moored near the junction of the river with the Clark & Skinner Canal in the late 1890s, is equipped with apparatus to enable one man to steer two boats at a time.

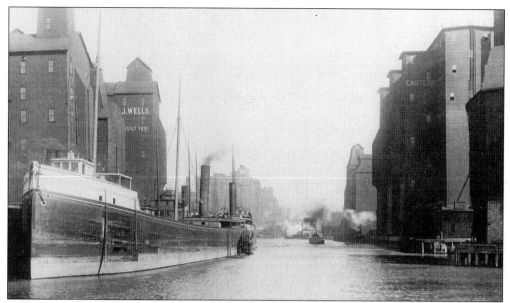

By the close of the nineteenth century, towering wooden grain elevators lined both banks of the Buffalo River, creating a commercial corridor for breadstuffs routed from Midwestern prairies to Eastern markets. Like Chicago, Buffalo was a city based on the exploitation of nature's bounty. The port's role in channeling the harvest stimulated new waterfront industrial architecture. This view looks southeast up the river from the foot of Washington Street.

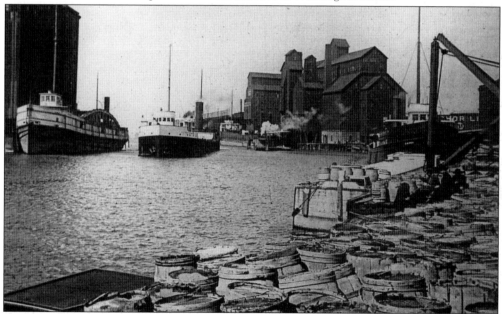

Beginning with the steamer *Spokane* (1886), steel-hulled bulk carriers such as the one in this stereopticon view became the vessels of choice for heavy commercial shipments. For carrying cargoes of iron ore, coal, and grain, they superseded ships with wooden hulls and "hog brace" arched trusses for longitudinal stability (left). Inner Harbor facilities reflected these shifts in ship design with increases in the size of slips and docks and scale of materials-handling operations.

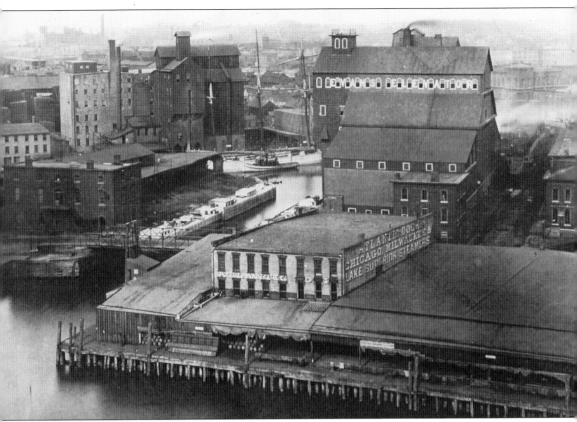

The Evans Ship Canal was a key link in the expanding network of Inner Harbor waterways. By the early 1830s, this privately-financed channel connected the Erie Canal with the Buffalo River (formerly called Buffalo Creek). This 1878 view shows the Evans Elevator (right center), one of Buffalo's characteristic grain storage facilities. In 1862 David Bell and the Evans shipping interests built the *Merchant*, the first iron-hulled, propeller-driven commercial vessel on the Great Lakes. No one was entirely confident the *Merchant* would float, so its launching on the Evans Canal was staged at 5 am to minimize potential embarrassment. After the Civil War, the Evans family's ships were absorbed into the Anchor Line, the marine arm of the Pennsylvania Railroad during an era when the major Eastern trunk lines also controlled shipping subsidiaries. That era ended in 1916 as federal legislation required railroads to divest themselves of their water transportation holdings. Vestiges of the Evans Canal remained visible until the City acquired the property in 1967 for waterfront development.

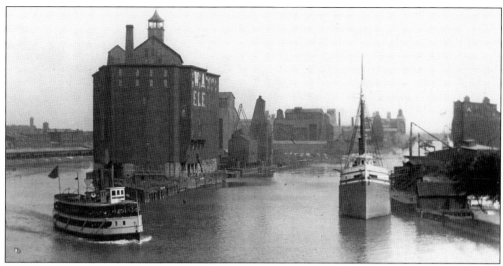

In the patchwork of slips and basins that was constructed to expand the Inner Harbor during the nineteenth century, the City Ship Canal was the centerpiece. Excavated by E.R. Blackwell during 1849–1852, the waterway extended south to the Lehigh Valley docks on Tifft Farm in the 1880s. This view shows the point where the Buffalo River (left) and the City Ship Canal (right) diverged at the Watson Elevator.

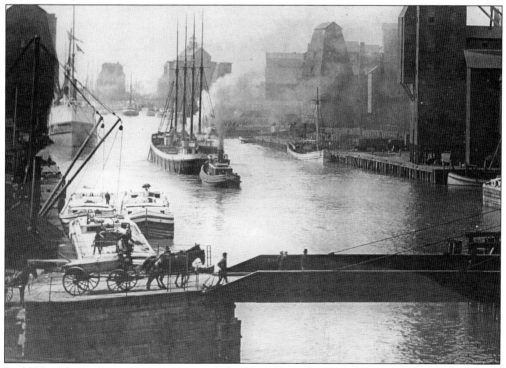

In 1888 pedestrians and wagons crossed the City Ship Canal on the South Michigan Street drawbridge, which had been damaged by an ice jam the previous winter. At right is the Frontier Elevator located on Hatch Slip. The squat tower adjacent is the Fulton, which could unload ships and transfer grain immediately to railcars or canal boats, but it lacked the storage capacity of larger elevators.

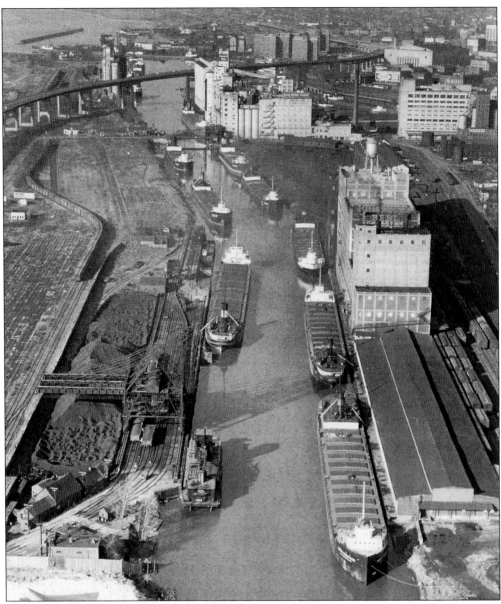

By the mid-twentieth century most of the Inner Harbor's earlier slips and dock facilities were displaced by the increasing size and scale of lake freighters and shoreside installations for handling cargoes. The City Ship Canal, however, remained a busy waterway as this aerial view taken at the close of the 1956 navigation season indicates. The view looks north toward the South Michigan Avenue bascule bridge, the new Skyway, and the Buffalo River. Moored along the City Ship Canal are a number of typical Great Lakes bulk carriers with their pilothouses forward, propulsion machinery aft, and hatches indicating the cargo holds mid-deck. Several of these ships held grain that would be unloaded through elevators at the General Mills and Pillsbury Flour milling complexes over the winter months. On the opposite bank is the iron ore unloading facility of the former West Shore Railroad, part of the New York Central system operated by the Ashtabula & Buffalo Dock Company. Also moored at this dock is the Ashtabula & Buffalo Dock Company's fuel lighter, the *West Shore* (lower left).

16

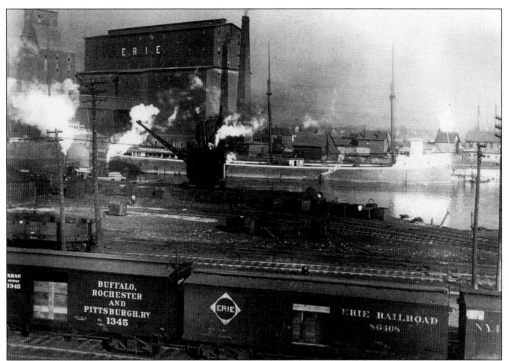

Although the transfer of freight and passengers between lake and canal was the foundation of Buffalo's early commerce, interchanges between the waterways and rail transportation eventually became even more significant. This view shows the Erie Railroad Yards along Ganson Street on the peninsula called Kelly Island that lay between the river and the City Ship Canal. The Erie Elevator was part of the waterfront from 1883 to 1913.

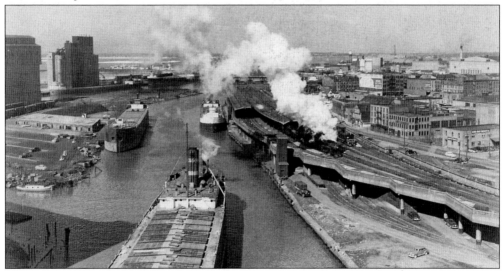

The major waterfront rail passenger station was the Lackawanna Railroad's monumental 1917 terminal. As seen from the Michigan Avenue lift bridge in 1949, a steam locomotive is pulling out of the vaulted train shed made of reinforced concrete on the upper level. Passenger service ceased here in 1962. Visible at right are buildings now in the Cobblestone Historic District, once a prime maritime manufacturing stretch between Illinois and Mississippi Streets.

17

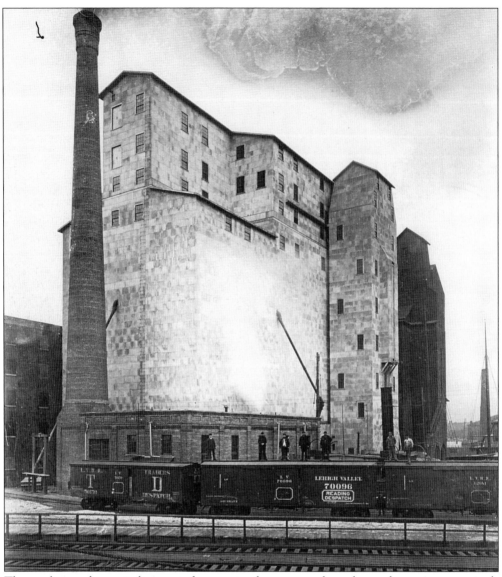

The steel tentacles encircling waterfront grain elevators, coal trestles, and passenger terminals tied Buffalo into the railroad system of the major Eastern trunk lines. Conflicts between the railroads and Buffalo's commercial interests occasionally threatened the city's preeminent position as a transshipment nexus during the latter nineteenth century. However, the opening of the spring wheat fields of the upper Midwest and the discovery of the Minnesota iron ranges furnished waterborne bulk cargoes that sustained local port operations into the twentieth century.

Buffalo Creek Railroad was a key link in the Inner Harbor rail network. Incorporated in 1868, the company functioned during most of its lifetime as a subsidiary of the Lehigh Valley and the Erie Railroads. The Buffalo Creek's tracks, a terminal switching line, connected with nearly all the line haul carriers entering the city, moving cars to and from waterfront facilities.

The grain elevator pictured here is the Marine, located on Kelly Island at the Hatch Slip. Note the spout descending from the gable end wall behind the chimney through which grain was loaded into railcars.

18

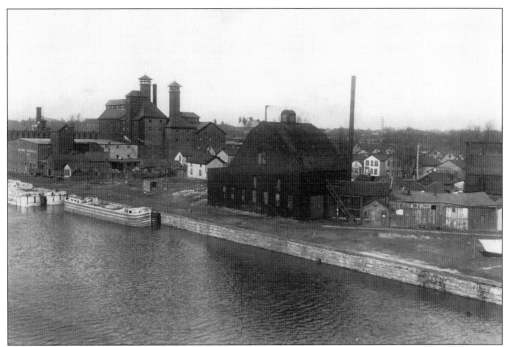

The route of the Erie Canal determined the location of many businesses on Buffalo's West Side. This *c.* 1898 view of the towpath between Georgia and Carolina Streets shows the Fisher Bros. Malt House (left) and Clark's Ice House (right). Malting, the partial germination and drying of barley, was essential for another Buffalo industry, beer brewing. Prior to the development of refrigeration, ice was harvested from frozen Lake Erie and stored for later use.

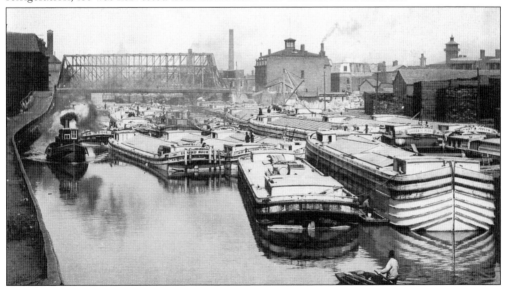

The enlarged "Clinton's Ditch" remained a key component of waterfront activity even during the railroad era. As seen from the Grand Trunk Railway Depot, a multitude of canal boats awaited cargoes or towing near the foot of West Genesee Street during the mid-1880s. The New York Central tracks crossed the canal on the larger of the two bridges in the background. Stewart Brothers Lumber Yard appears at the extreme right.

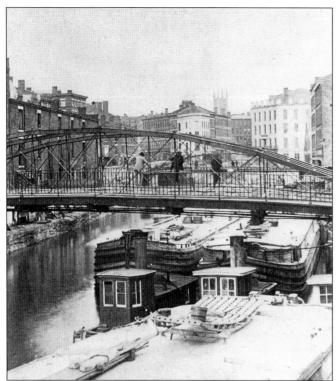

Commercial Slip, an improved version of Little Buffalo Creek, was a principal artery for canal boats transiting the Buffalo River. The portside denizens lounging on the Water Street Bridge before the DL & W Railroad had intruded on the scene were gazing toward the canal, Pearl Street, and the terrace. The beauty of Buffalo's lost waterfront architecture is apparent in this photograph.

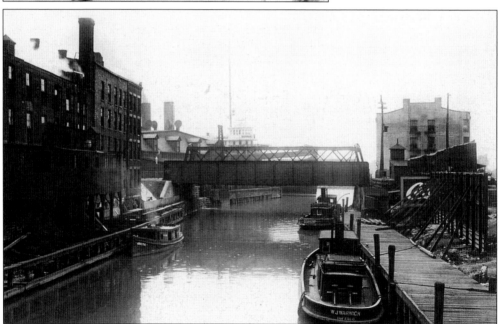

This view of Commercial Slip looking toward the Buffalo River was taken by the New York State Engineer's western division office on August 12, 1914, just before state and railroad construction projects began. A plate girder bridge carried the DL & W's North Pier track over the slip with the Water Street Bridge immediately behind. The large vessel was docked at the DL & W riverfront freight house.

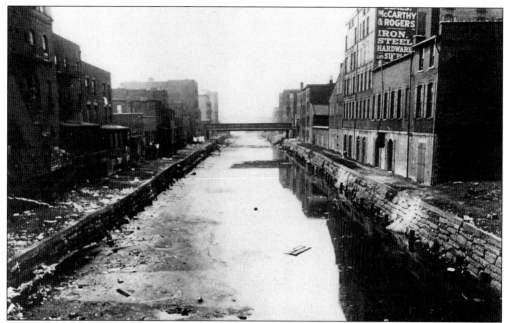

Completion of the barge canal system in 1918 rendered the former Erie Canal obsolete. Where the two canals diverged, the older thoroughfare, once choked with boats, was abandoned. This 1926 view from the Commercial Street Bridge looks northwest toward the Evans Street Bridge. The hardware firm of Beals, McCarthy & Rogers and its predecessors had occupied the building at 44–50 Terrace (right) since 1850.

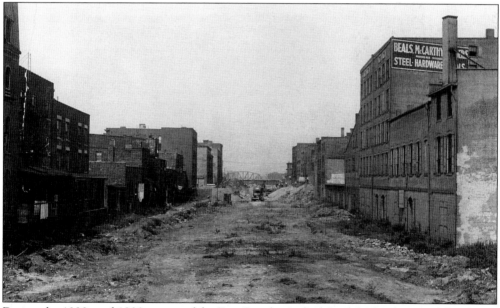

During the 1920s and 1930s traces of the Erie Canal vanished from the landscape as abandoned sections were filled in. This photograph was taken from the spot where Commercial Street once crossed the canal. Buildings on the left were part of Buffalo's infamous Canal Street District, whose story has been recorded in *America's Crossroads* by Michael Vogel, Edward Patton, and Paul Redding.

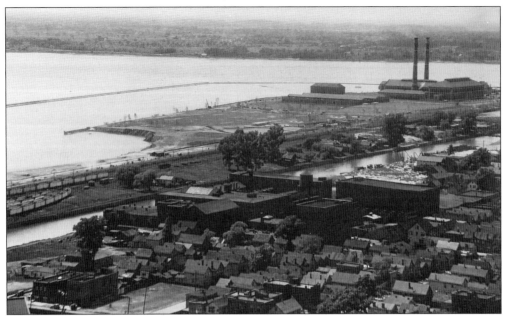

This 1932 aerial shows the principal waterways that have touched the West Side of Buffalo. The Bird Island Pier divides the turbulent Niagara River from the calmer waters of the 1918 Black Rock Canal; vessels could reach the Tonawandas via the later route. The Erie Canal, still containing a ribbon of water, is also visible. Centennial Park, now LaSalle Park, was being developed south of the Colonel Ward Pumping Station from landfill (right).

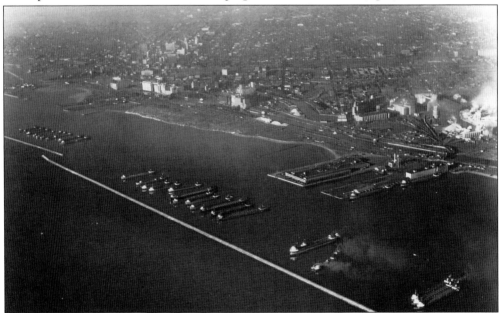

Buffalo's compact Inner Harbor could not accommodate all the vessels seeking dock space at various times during the year. Between 1869 and 1911 the U.S. Army Engineers designed a series of offshore breakwaters that provided sheltered anchorage in Lake Erie. This Outer Harbor was particularly valuable as a haven for the large fleet of ships that wintered over in Buffalo to supply local grain elevators and flour mills.

Two

Commerce and Cargoes

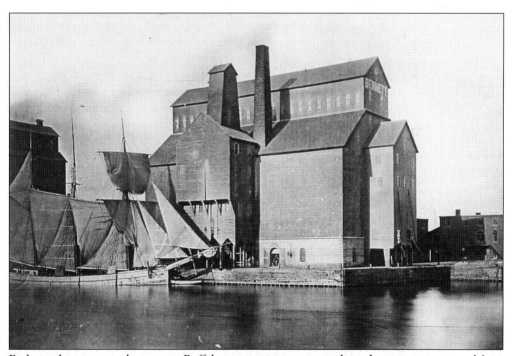

Early in the nineteenth century, Buffalo was a major grain trade and processing center. Many of the grain handling operations were clustered around the Inner Harbor and along the Black Rock and Erie Canals. Large transfer elevators, such as the Bennett (pictured here about 1870), handled what author Anthony Trollope called "wheat running in rivers." Elevators could unload, weigh and sort, store, and transfer huge amounts of grain from and to ships, or into storage for local use or for future transport to hungry Eastern cities.

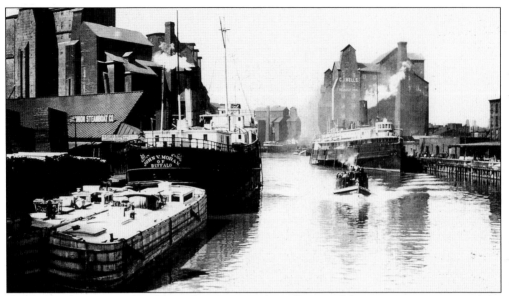

Large grain carriers such as the *John Moran* and smaller canal boats were mainstays of the Buffalo grain trade. Freighters unloaded their cargoes at elevators such as the C.J. Wells, where the grain was weighed and sorted according to its designated owners, including mills or grain traders. Transfer to canal boats for shipping along the Erie Canal to Eastern cities could occur the same day the grain arrived.

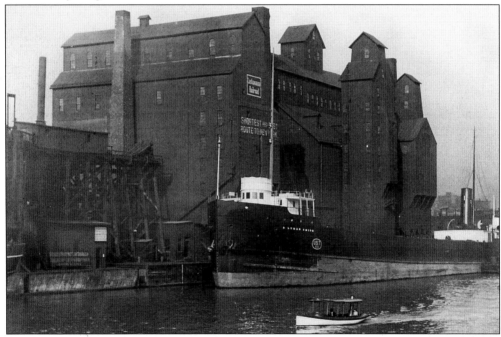

Dozens of railroads, such as the Lackawanna, dramatically improved Buffalo's grain trade. By the 1890s, the turn-around capability of Buffalo's elevators was enhanced by the movement of large grain orders by rail. Buffalo was a part of the New York City Port Authority Lighterage (or unloading) District, because within thirty hours grain could be unloaded at Buffalo elevators, sorted, reloaded in railcars, and sent to New York for export overseas.

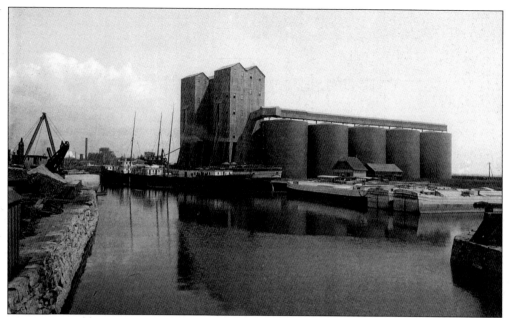

Changes in ship capacity, building materials, grain demand, and capital wealth encouraged the construction of ever-larger elevators. In 1897 Buffalo grain merchant Edward Eames built his two-million-bushel, steel-bin electric elevator on the river at Ohio Street. One of the first electrically-powered elevators, it heralded Buffalo's increasing prominence in the international grain trade at the end of the nineteenth century.

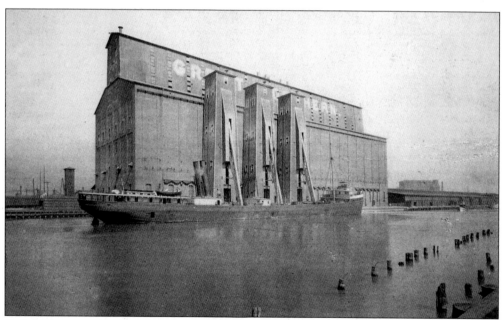

Buffalo's importance enticed Great Northern Railway owner, James J. Hill, to purchase land along the City Ship Canal in 1883 where he built his 2.5-million-bushel, steel-bin Great Northern Elevator in 1897. Hill was not the first absentee grain magnate, but his presence heralded a shift away from local control as Buffalo increasingly became the focus of international grain capital.

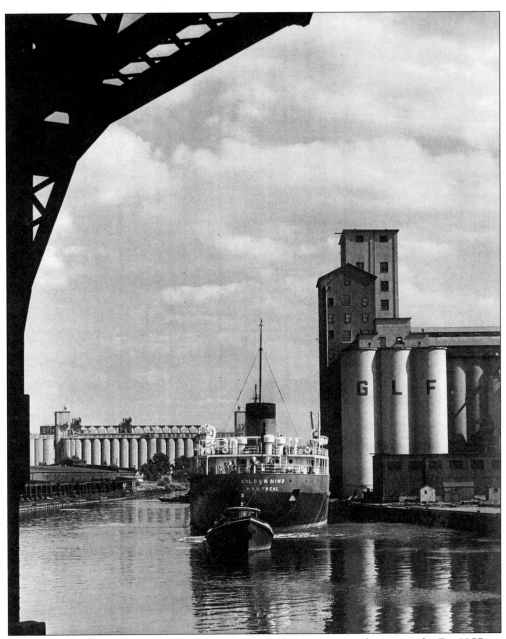

During World War II Buffalo expanded its role in the international grain trade. By 1957 no major elevator was locally owned, and three of the world's largest grain merchants, Continental, Cargill, and Peavey, controlled elevators on the river and Outer Harbor. The government's Commodity Credit Corporation, which arranged grain surplus exports through the large private companies, made storage of huge supplies a necessity, and demand for elevator space attracted larger ships such as the *Golden Hind* to Buffalo to keep silos filled. In 1959 the opening of the St. Lawrence Seaway allowed ships to bypass Buffalo and sail directly to Eastern ports, but the most serious impact on transfer elevator business came from Buffalo's loss of preferential railroad rates that would have kept the grain trade competitive. By the 1970s all transfer business was gone.

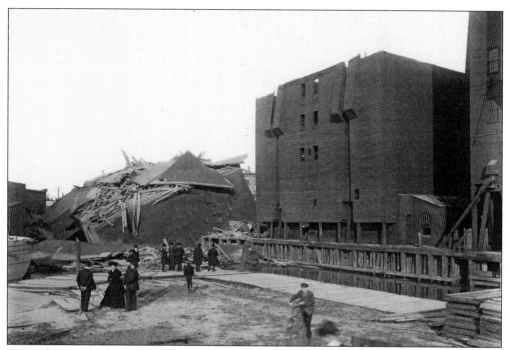

Grain elevators built of wood were subject to the dangers of structural failure, fire, and grain dust explosions. On October 30, 1904, the Ontario Elevator collapsed into the Evans Ship Canal. A spate of lawsuits ensued as various parties debated the cause of the accident and related liability. The verdict came down against the owners and managers due to defective design and improper maintenance of the facility.

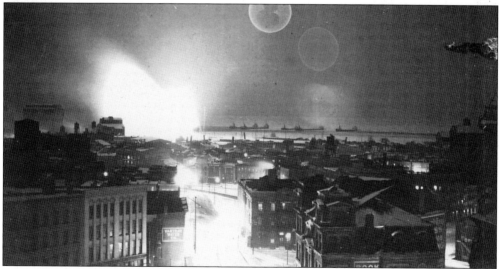

A fireball in the night, the March 9, 1914 conflagration at Connecting Terminal Elevator A, lit up the waterfront. Night watchman Alex McKay discovered the blaze about 7:30 pm; five hours later the 1882 elevator lay in ruins. Connecting Terminal was an outpost of the Pennsylvania Railroad's empire. A year later another of the Pennsy's wooden elevators at Erie, Pennsylvania, also burned. These events prompted the rebuilding of the facilities as fireproof reinforced-concrete silos.

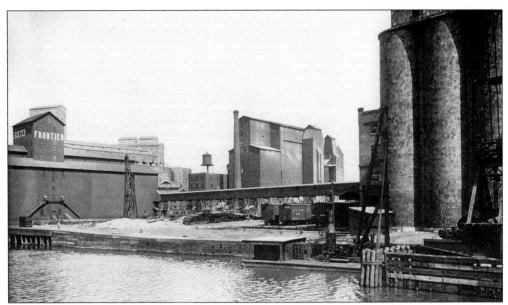

Around 1900 elevator designers sought cheaper and less combustible materials. They experimented with storage bins built of steel, tile, or reinforced concrete. Pictured at right are the 1903 tile bins of Washburn-Crosby's new flour mill. Minneapolis-based Washburn-Crosby, a recent arrival in Buffalo, initially received waterborne grain through the wooden 1886 Frontier Elevator (left) on the City Ship Canal. An overhead conveyor belt (center) linked the two facilities.

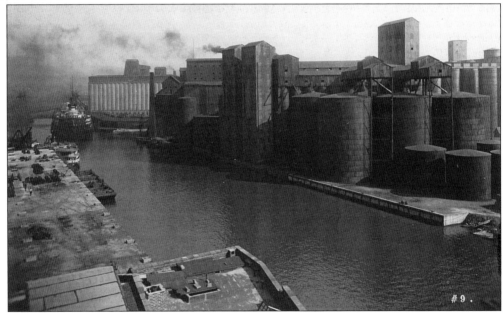

Use of novel fireproof materials required improved understanding of these components and their adaptability to grain storage. Consequently, new engineering firms displaced traditional elevator contractors. In this 1915 photograph, the evolution of elevator design marked the Buffalo waterfront: visible are the steel tanks of the Great Eastern (right), the wooden 1881 and 1894 Marine Elevators (center); and the reinforced concrete silos at the 1911 Kellogg (left).

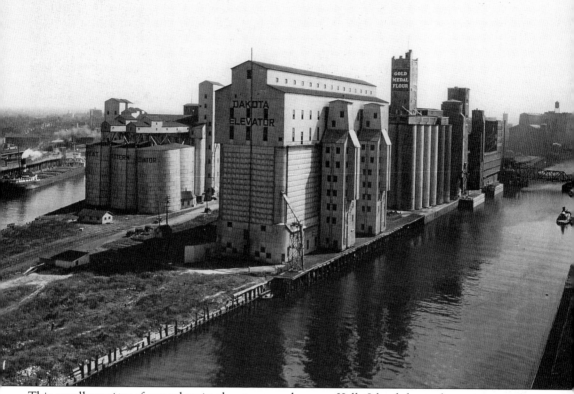

This excellent view of several grain elevator complexes on Kelly Island shows the monumental scale of the fireproof elevators erected during the early twentieth century. The Great Eastern Elevator (1901) on the Buffalo River was designed and built by Steel Storage and Elevator Construction, the firm that had created the electric elevator four years earlier.

In contrast to the exposed steel tanks of the Great Eastern, the Dakota Elevator (1902) concealed its unusual bins behind a facade of corrugated iron panels. The Dakota's dock along the City Ship Canal featured twin marine towers for unloading lake vessels as well as a spout for loading canal boats or small steamers transiting the Welland Canal to Montreal.

Beyond the Dakota lies the reinforced-concrete Frontier Elevator, which grew in stages between 1904 and 1925 as part of the General Mills complex (formerly Washburn-Crosby). In the distance (right) is the 1897 Great Northern Elevator, a pioneering combination of steel bin construction and electric operation. Also visible is the flour mill built by Pillsbury in 1924.

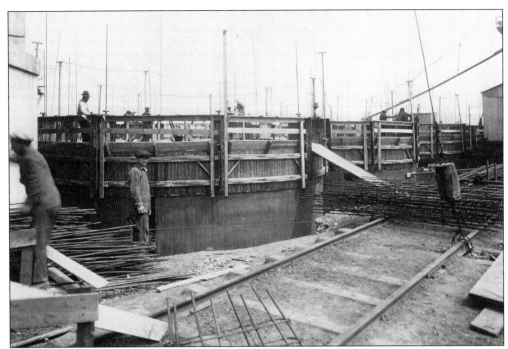

The round silo was well-suited for innovative construction methods, such as "slip forms" that permitted the continuous pouring of concrete, thus saving time and expense. The following series of four photographs illustrates how the storage bins for the 1925 addition to the Superior Elevator were built using the slip form technique. This photograph taken on April 23 shows the wooden forms and screw jacks used in the process.

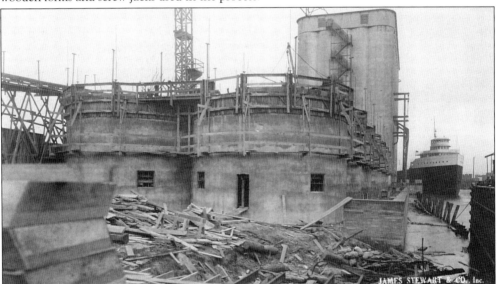

The 1925 addition included seven tanks in a double row enclosing six smaller bins. On May 7, the bin walls inched upward. Henry Baxter, whose family's engineering firm supervised this construction, later wrote, "Workers operated the jacks at a rate calculated to raise the form about six inches an hour. This rate gave concrete time to set at the bottom before being exposed by the slowly rising form."

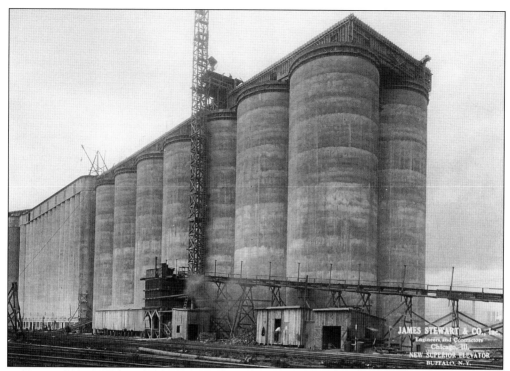

By June 18, the slip forms had reached the top of the bin height, and construction was proceeding on the distribution floor cupola. Writing about the practice of slip forming, engineers R.H. Folwell and R.P. Durham observed, "The principal thing in their operations is to keep the form deck level as it is jacked upward. Another thing is to avoid jacking faster than the concrete sets."

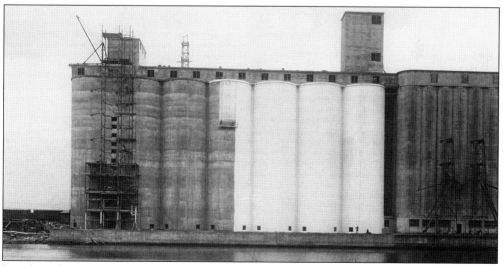

Reinforced steel within the elevator walls handled stresses that concrete alone could not tolerate. By July 16, the various phases of concrete work on the Superior Elevator annex were virtually completed. Construction was underway on the structural steel framing of the stationary marine tower visible at the left end of the addition. That tower would house the equipment for unloading grain from lake ships.

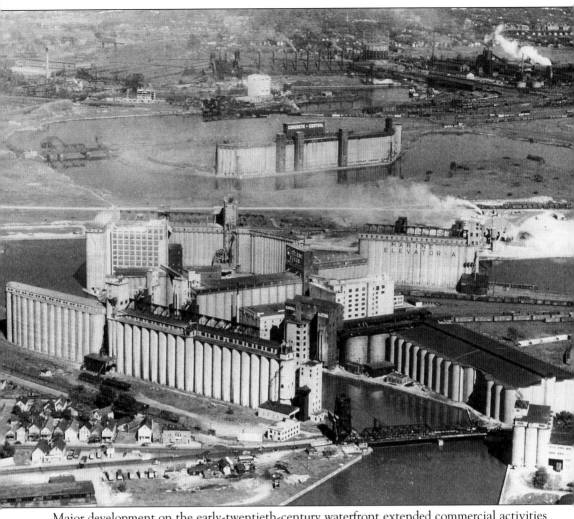

Major development on the early-twentieth-century waterfront extended commercial activities beyond the earlier limits of the Inner Harbor and up the winding Buffalo River. By the 1940s huge concrete grain elevators crowded the shoreline above the Ohio Street Bridge (bottom). Though similar in structure, these elevators discharged two different functions: transferring and storing grain. Transfer elevators received grain via lake vessels or railcars; they cleaned, conditioned, and stored their grain receipts until it was time to ship cargoes out by canal, rail, or in some cases, trucks. The ability to perform all these related operations efficiently was the hallmark of a well-designed transfer elevator. As one trade journal remarked, "Conditions at Buffalo are such that rapidity in handling grain is vital in establishing the desirability of any one elevator." Transfer elevators thus were also more vulnerable to shifts in trade routes than the second type of waterfront elevator, those serving as storage annexes for Buffalo-based processing facilities such as flour and cereal mills or malt houses.

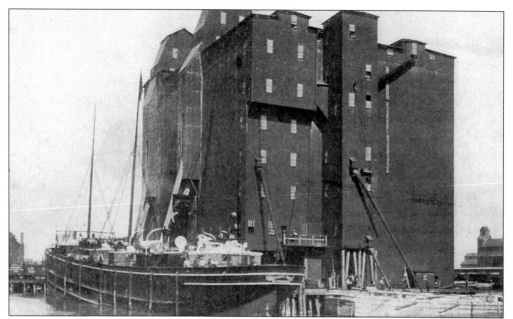

Waterfront elevators acted as intermediaries during the nineteenth century. They transferred grain from one form of transportation to another but did not process cargoes themselves. The wooden Dakota Elevator, located at Hatch Slip and the City Ship Canal, performed classic intermodal marine transshipment. The lake vessel on the left was being unloaded; previously stored grain was simultaneously loaded through spouts into the canal boat on the right.

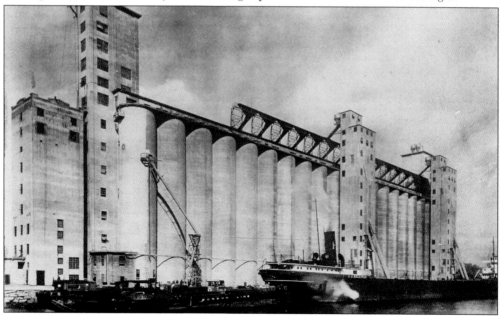

During the early twentieth century grain elevator operations remained largely unchanged. Here at the 1928 Standard Elevator, the essential elements of marine transshipment were still in place. Grain was being raised from the vessel on the right and carried into the elevator through the marine towers and the Y-shaped rooftop spouts. Cargoes were also loaded into canal barges through the dock spout at left.

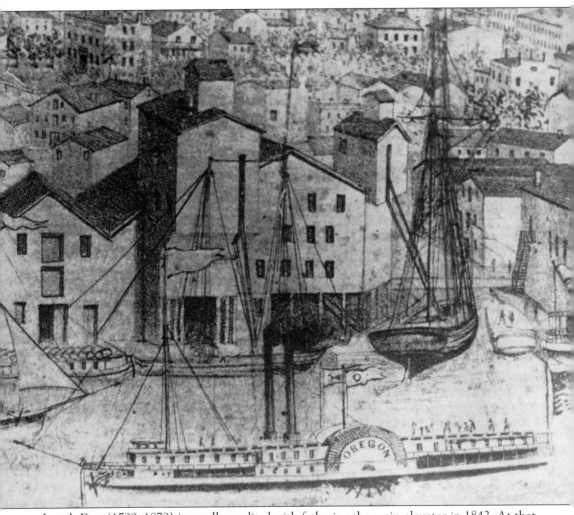

Joseph Dart (1799–1879) is usually credited with fathering the grain elevator in 1842. At that time Midwestern grain was flooding the Buffalo port and taxing manual handling methods to the limit. Dart decided to replace the backs of Irish laborers with the world's first steam-powered storage and transfer elevator. He acknowledged an explicit debt to the mechanized bulk-handling methods first devised for flour mills by Oliver Evans of Philadelphia. It was engineer Robert Dunbar (1812–1890) who solved a critical problem, however, by adapting Evans's elevator leg to lift grain from a ship's hold with an endless string of buckets. Flour mills at nearby Black Rock may have used earlier versions of Dunbar's "adjustable marine leg." Dunbar went on to establish a distinguished international career in this specialized field of machinery design and construction. This lithograph shows the Dart Elevator with its original marine leg, plus a second leg added in 1846, unloading two sailing vessels, one on the Buffalo River the other on the Evans Ship Canal (right).

34

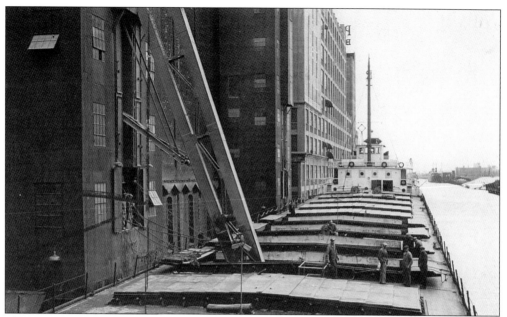

The actions of the marine leg fascinated tourists, who compared the mechanism to a mosquito's bite or an elephant's trunk. A leg at the Great Northern Elevator is seen here working in the hold of a laker in 1946. Robert Dunbar's invention did not unload vessels unaided. Also visible beneath the leg are the lines for controlling power shovels that moved grain to within reach of this inflexible leg.

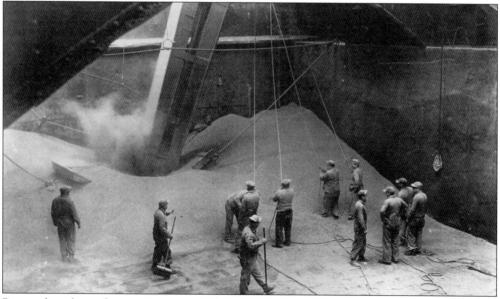

Power shovels used in conjunction with marine legs were patented as early as 1864. The grain scoopers, the men who operated the shovels, engaged in Buffalo's most distinctive waterfront occupation. Many scoopers were from South Buffalo Irish families. In addition to handling the clutch lines that regulated a pair of power shovels, members of the International Longshoremen's local #109 also shoveled and swept grain by hand in a dusty and debilitating environment.

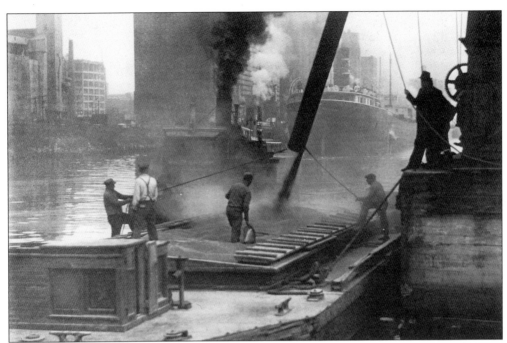

The scene is the north end of the Connecting Terminal Elevator where the dock spout is delivering grain from storage bins to a barge. Elevators also loaded pocket-sized steamers that sailed through the old Welland and St. Lawrence Canals to Montreal. Loads had to be "trimmed" (or leveled) and evenly distributed so as not to destabilize the craft.

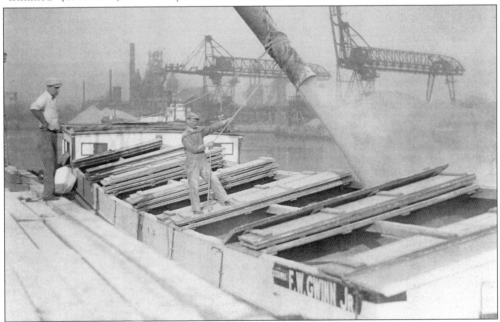

Wilbur Porterfield observed when taking this photograph for a Buffalo newspaper that loading as well as unloading grain barges was dusty work. While prowling about the waterfront during the 1930s, Porterfield captured this photograph showing crews loading a barge at Marine A Elevator on the Buffalo River.

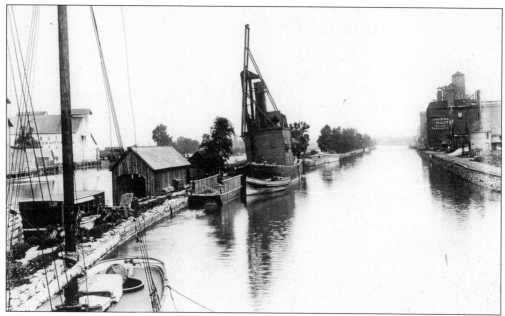

Floating grain elevators were a novel adaptation of Dart's invention. More marine towers than storage facilities, they moved grain from one vessel to another or were used by small elevators and mills that had no unloading facilities of their own, such as Queen City Mills and the Frontier Elevator on Squaw Island.

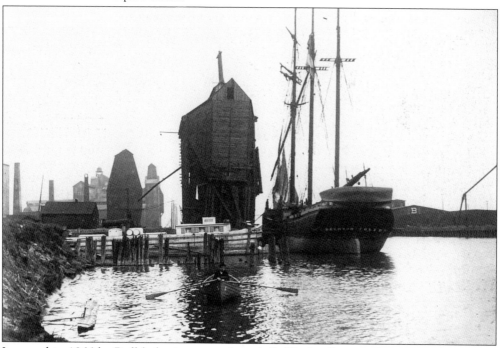

Invented in 1866 by Buffalo businessman Arunah B. Nimbs, floating elevators could store up to 5,000 bushels of grain, but their real utility was in transferring grain rapidly. The floating elevator of C. & J.M. Horton, pictured here in 1875, served the Central Wharf in Buffalo harbor and could move 72,000 bushels a day, nearly the equal of many larger elevators.

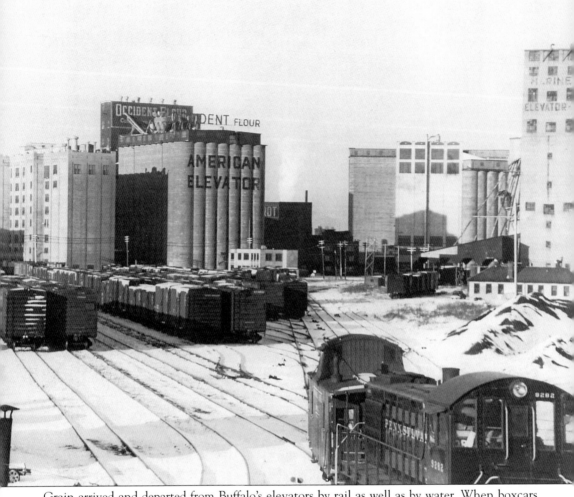

Grain arrived and departed from Buffalo's elevators by rail as well as by water. When boxcars carrying grain arrived alongside an elevator, the most common procedure for many years was to unload the cars with power shovels comparable in some respects to the ship shovels handled by the scoopers. An 1891 article in *Scientific American* described the process of emptying railcars in this way, "This is a scraper about three feet square to which a rope is attached. The rope is attached to steam apparatus by which it is taken in at the proper time, as if on a windlass. The operative draws the shovel back into the car of grain and holds it nearly vertical and pressed down into the grain. The rope draws along the shovel with the grain in front of it and a number of bushels are delivered at each stroke. In this way a couple of men can very quickly empty a car. The movements of the shovels succeed one another with sufficient rapidity to keep the men in active movement."

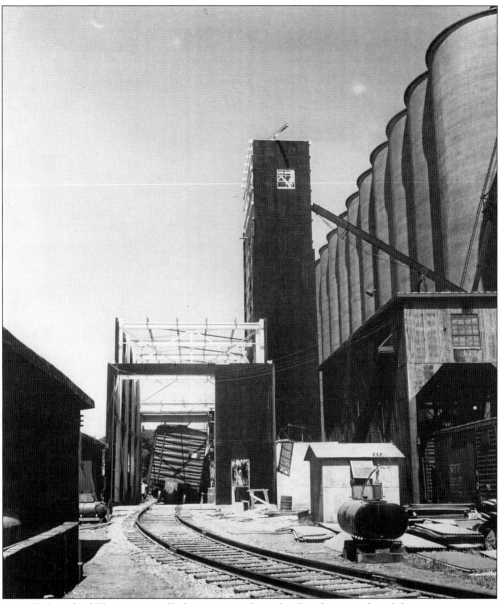

In 1955 Standard Elevator installed equipment for unloading boxcars that did not require power shovels or their operators. The addition was a second-hand car dumper that unloaded a car by tilting it on a cradle so that grain poured out the open doors. Technology of this type had been available for at least thirty-five years. However, in the mid-1950s, the St. Lawrence Seaway was under construction and its shadow loomed over the port of Buffalo. Grain shippers projected a potential decline in local lake transshipments, but some elevator operators anticipated a corresponding increase in rail traffic. Despite its relative antiquity, the car dumper could empty a freight car in about six minutes, considerably faster than the car shovels in the adjoining pits. Within a decade, though, covered jumbo hopper cars began replacing boxcars for shipping grain. The hopper cars discharged their contents through openings in the bottoms, so it was no longer necessary to empty cars by tilting them. The powerful mechanism in the car dumping shed was eventually taken out of service.

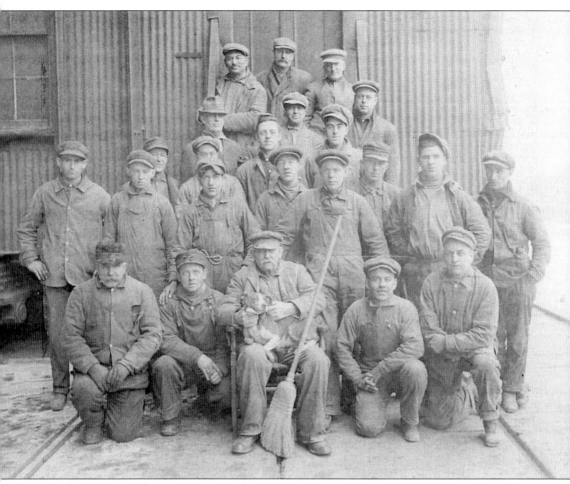

The backbone of all waterfront grain elevator functions was the crew. The Dakota Elevator was one of Buffalo's most modern in 1915, and the crew operated and maintained the machinery, moved, weighed, and sorted the grain, and provided security by keeping watch for dangerous conditions, particularly fires. The Dakota Crew members were, from left to right: (front row) Tom Kytes, Jack Welch, Henry Riley (with Trixie), Bart Connors, and Jack Kitching Sr.; (second row) George O'Keefe, Ed Myers, Jack Kitching Jr., Bob Arber, Earl Callinan, Pete Arbor, and Ralph White; (third row) Frank Woodside, Roy Geyer, Frank Arber, Mike Hoolihan, and Joe Meyers; (fourth row) Earl Finley (superintendent), unidentified, and Bill Walsh; (back row) George Burkhardt, John Campbell, and Bill Welch. Buffalo's grain workers are commonly identified as Irish, but the Dakota crew indicates that a wide range of nationalities populated these waterfront occupations.

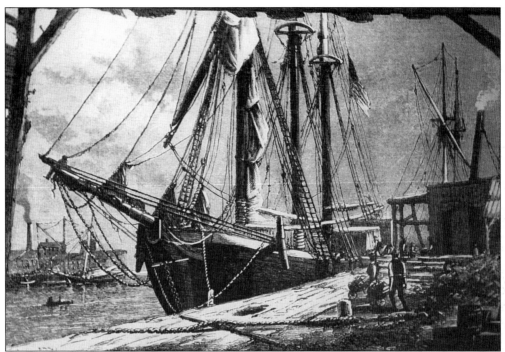

Anthracite coal was one of the principal fuels for steam-powered industrial expansion during the nineteenth century. Shipments of the "black diamonds" from northeastern Pennsylvania reached Buffalo via canal as early as 1842 and by rail in 1861. Vessels that carried Midwestern grain down to Buffalo often returned up the Great Lakes carrying coal. Men with wheelbarrows loaded these cargoes of coal by hand. It was extraordinarily hard work.

To eliminate delays, expense, and jobs associated with manual loading methods, the anthracite shipping railroads built large wooden trestles for the lake transfer trade. The most prominent coal trestle on the waterfront belonged to the Lackawanna Railroad (DL & W). It commanded the entrance to the Buffalo River at the site of the former U.S. North Pier. Legal disputes over ownership of the title to the property flared up in 1879, 1885, and 1913.

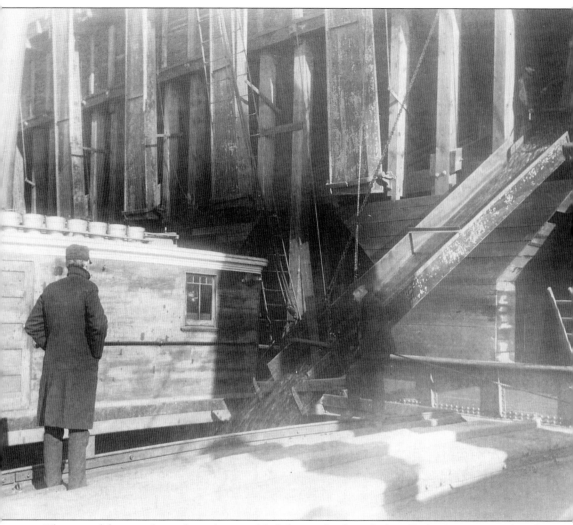

The giant lake transfer coal trestle resembled the ore loading docks of Lake Superior. Railroad cars spotted along the top of the trestle dumped their contents into storage pockets. Ships moored alongside the trestle received that coal in their holds. Chutes were lowered, and anthracite streamed out of the storage pockets simply from the pull of gravity. The ship's holds were filled in a predetermined sequence so as not to overstress the hull or risk capsizing. Coal cargoes were trimmed in the hold much like grain shipments. Bulk cargo carriers of all descriptions stocked up at the Lackawanna trestle during its operation from the early 1880s to 1915.

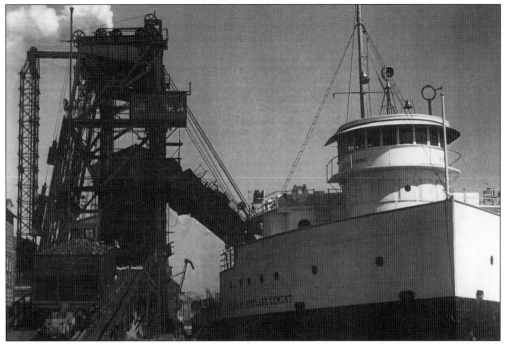

In 1916 the DL & W Railroad replaced its original trestle with a more rapid handling facility. This Wellman-Seaver-Morgan vertical dumper inverted an individual railcar to distribute its contents into the hold of a vessel at dockside. The dumper is shown here loading the *Standard Portland Cement*, one of the bulk carriers of Buffalo-based American Steamship Company managed by Boland & Cornelius, a renowned Buffalo maritime firm.

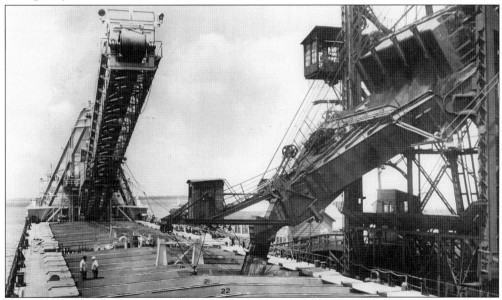

The DL & W's 1916 car dumper remained a fixture on the waterfront into the Seaway era. This view shows a railroad gondola car being inverted at the top right in 1959. *McKees Sons* was taking on coal after delivering limestone to Bethlehem Steel's Lackawanna plant. This was the first delivery into the plant after the end of the 116-day steel strike.

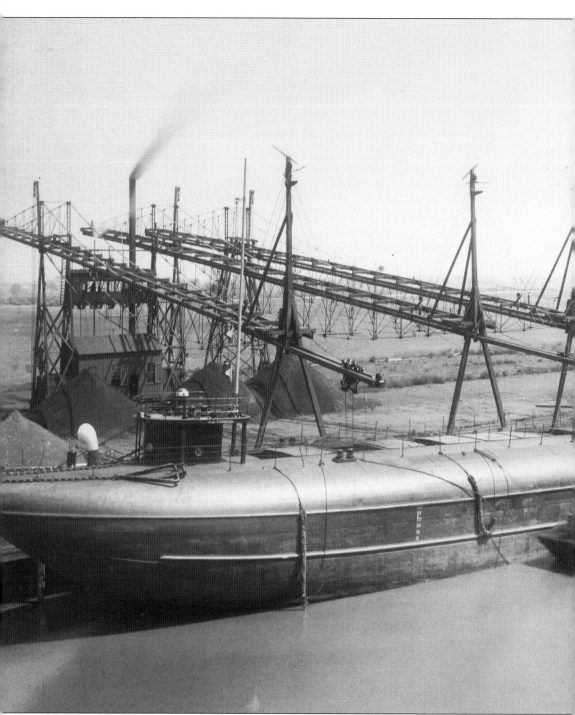

No aspect of Great Lakes history is more saturated with folklore and romance than the iron ore trade. During the nineteenth century a rising tide of raw materials floated down the lakes from Minnesota and Michigan to feed the insatiable blast furnaces of the iron and steel industry. Existing ship designs and unloading methods could not handle the sheer volume of minerals being dug out of the earth. This tableau at the Lehigh Valley Railroad's Tifft Farm docks shows

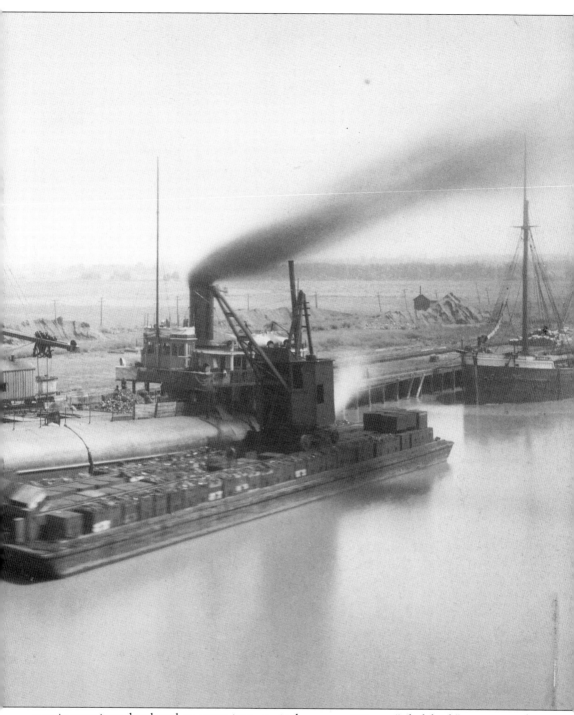

two innovations developed to move iron ore in large quantities: a "whaleback" steamer and a mechanical unloading rig. The vessel was the *A.D. Thomson* (1891), part of a fabled fleet designed by Captain Alexander McDougall. Like grain elevators and coal trestles, the ore-unloading equipment from the Cleveland works of Alexander E. Brown replaced manual labor.

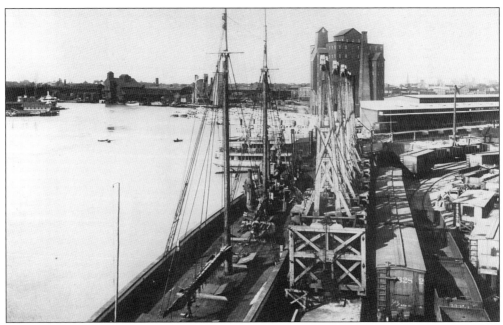

Several types of ore-handling equipment could be seen on the waterfront. Shown here are Thornburg hoists at the DL & W docks situated between the railroad's coal trestle and Erie Basin. The six arms of the design could dip to one side to unload vessels and then pivot in the opposite direction to deposit the contents of the buckets into railcars.

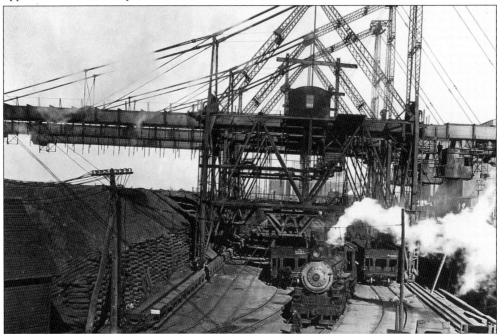

This view of the West Shore Ore Dock was taken on October 11, 1916, and shows the three Brown electric unloaders then in use. To unload, vessels in the City Ship Canal would tie up at the right, where clamshell buckets lifted iron ore from the holds in 7-ton bites. The unloading rigs could then transfer the cargo either to railcars (center) or to stockpiles for storage (left).

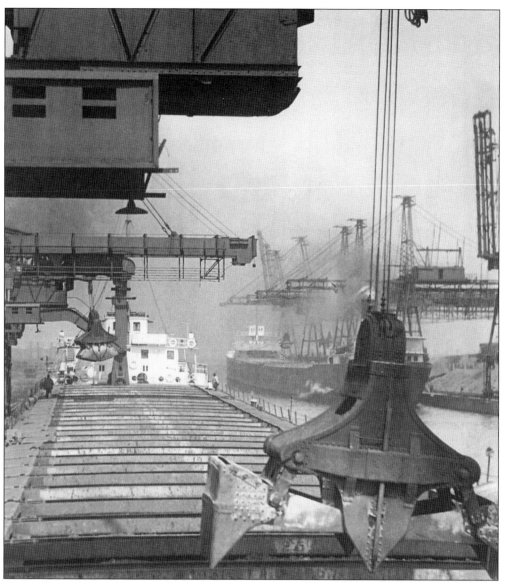

Two different types of ore handling equipment unloaded the same vessel at the Pennsylvania Ore Dock on the Union Ship Canal. Closer to the camera were two 5-ton-capacity clamshell buckets that hung from a pair of Brown electric unloaders. The nearer bucket is shown descending into the hold to grab some of the cargo. The other is being trollied over to the dock, where it would discharge its load into railcars or onto stockpiles. The Brown unloaders shared the dock with a Hulett unloader, one of the most successful mechanical unloading devices ever designed. The Hulett's rigid arm, where the operator rode, is disappearing into a hatch at the forward end of the ship. The clamshell buckets of the Brown unloaders could not clean out the cargo spaces as thoroughly as the more flexible Huletts. Hand labor and mechanical equipment such as a small bulldozer had to move cargo from remote sections of the hold to within reach of the clamshell bucket. On the opposite bank is the Hanna Furnace ore dock (right).

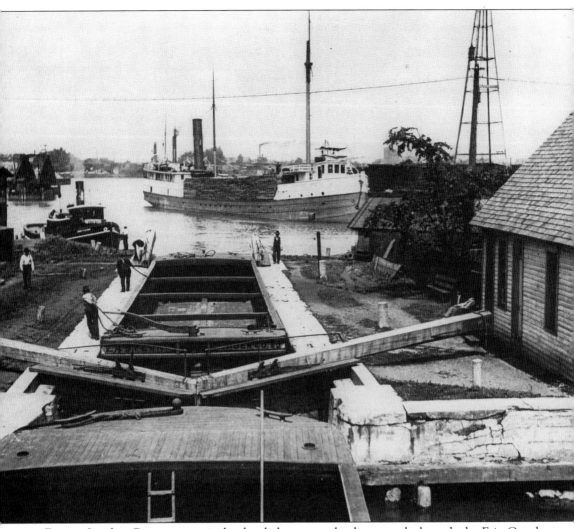

Eastern Lumber Company ran its lumber lighter, or unloading vessel, through the Erie Canal lock to the company's yard on Ellicott Creek. This 1912 picture looks from the lock toward the Niagara River and the large "lumber hooker" steamship carrying the awaiting cargo. The ships were called this because they often hooked on a series of barges to carry additional loads behind the main vessel. Lighters did transfer work in places where the steam vessels were just too large to maneuver, such as the canal locks, or where it was more efficient to break down a smaller load and give it to the lighters for delivery.

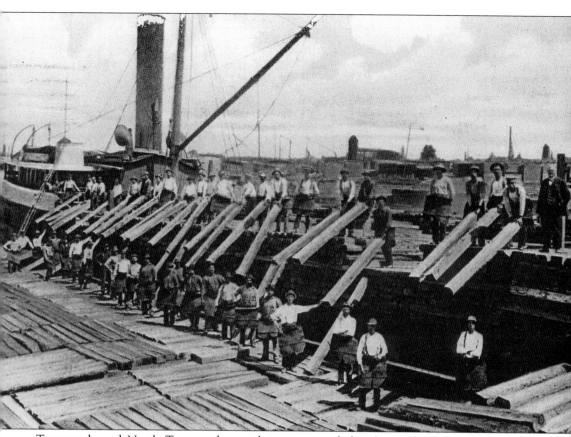

Tonawanda and North Tonawanda together constituted the "largest lumber market in the world," and serving that mighty industry was an unusual occupation—that of the lumber shover. According to the *Tonawanda News*, shovers worked in gangs of thirty-two men per barge to get all of the lumber up from the hold or off the deck onto the dock. The lumber came in four lengths: 10, 12, 14, and 16 feet (most of a 1-inch thickness). The widths varied, however, and determined how many boards were handled at a time. Four-inch boards were picked up six at a time; others were handled in different amounts. The object was for the men on deck to pass the laths to a man on the dock. But a 3-inch plank 36-inches wide quickly taught workers what hard labor really was. At their mid-day break, the men consumed a keg of beer, most of which was almost immediately sweated off. The only pleasure came when the majority of lumber was on deck; then it was downhill work.

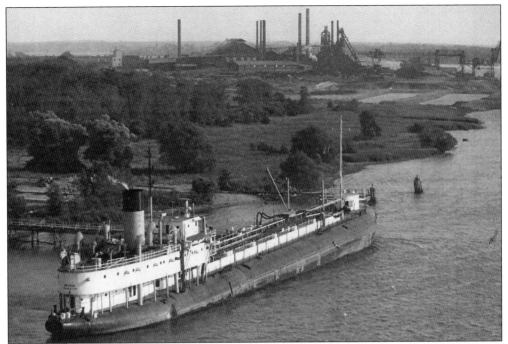

A living part of Great Lakes heritage, the whaleback tanker *Meteor* delivered liquid bulk cargo to an oil dock on the Niagara River above the South Grand Island Bridge. The vessel began life in the mid-1890s as the *Frank Rockefeller*, part of Alexander McDougall's famous fleet. It also sailed as the automobile carrier *South Park*. The *Meteor* is now preserved as a museum ship at its birthplace in Superior, Wisconsin.

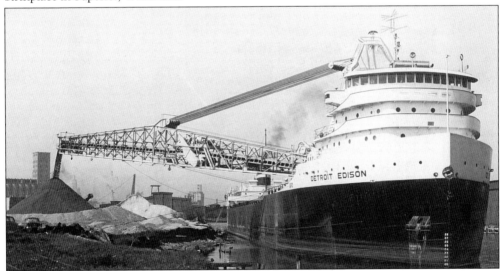

"No Help Needed" was the caption accompanying this newspaper photograph, and self-unloading vessels such as the *Detroit Edison* (shown here) certainly had a major impact on Great Lakes waterfronts and employment. Self-unloaders could discharge their cargoes without the aid of the massive dockside equipment that had become such a prominent visual feature of the industrial landscape. Early self-unloaders such as the *Wyandotte* (1908) primarily carried coal and limestone.

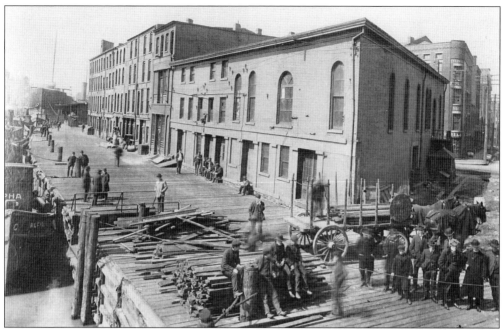

Smaller domestic commerce transpired daily on the docks and wharves along the river and canals. Front Street Dock, pictured here, was one of the major commodity loading and unloading areas. It was the city's central commercial landing before the advent of large warehousing facilities in the Outer Harbor. Small lumber dealers are shown moving their goods to carts for delivery to their yards.

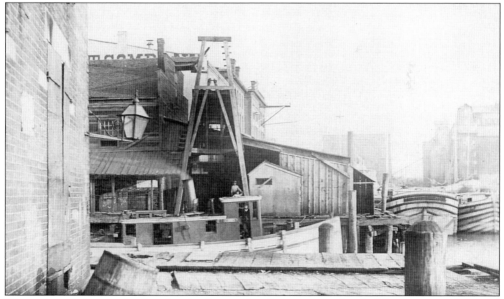

Slips allowed ships to load and unload immediately next to individual businesses and central storage facilities. This slip serviced the DL & W Railroad freight house (shown just beyond the slip dock). The A-frame visible here presents a side view of a moveable ship ladder. Dozens of these dotted the waterfront, allowing crews to board ships of any height and removing the need for highly specialized docking facilities.

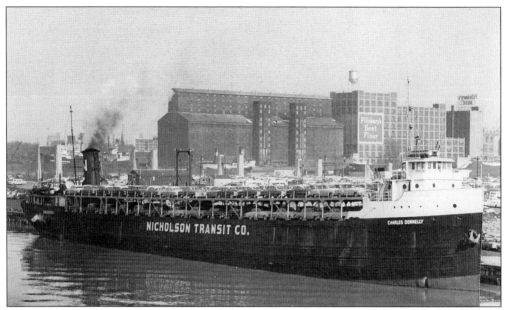

The auto carrier *Charles Donnelly* entered the Outer Harbor for the opening of the navigation season in April 1954. Loaded with automobiles destined for the Buffalo market, the Detroit-based Nicholson carrier was a regular presence in Buffalo. Although Ford Motors produced cars on Fuhrmann Boulevard adjacent to the waterfront, demand for other makes and models created a brisk traffic for the auto transit line.

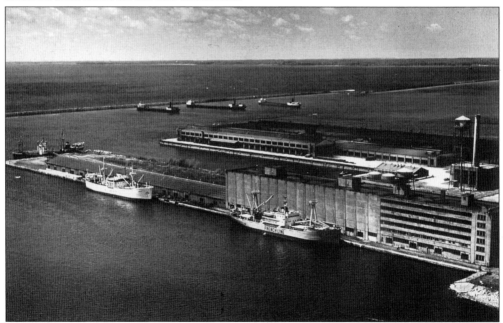

"Salties," as transoceanic freighters are known, are pictured alongside Merchants Warehouse in the early 1950s. Buffalo's waterfront supplied markets around the world with the commodities needed for post–World War II reconstruction. By 1958 foreign trade at the port had tripled over the previous year. Buffalo was the fifth-busiest port during the first half of the twentieth century and remained a leading Great Lakes port for years after World War II.

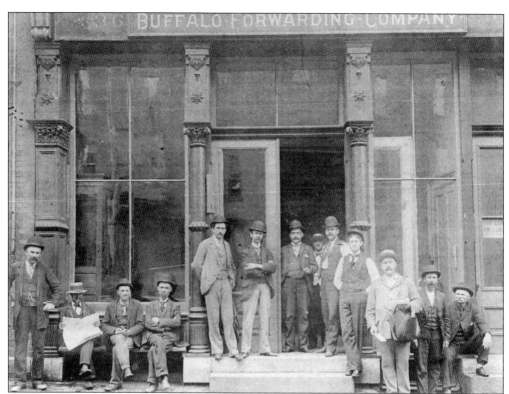

The Buffalo Forwarding Co. was typical of the waterfront enterprises that handled the transfer of commodities. Begun in 1889 by Frank Beadle and Willis Jacus, the company operated for less than a decade, first at 39 West Seneca and then across the street at 36 Seneca (pictured here). By 1898 the partnership was ended with each man continuing his own lucrative freight handling and commission business independently.

Prior to development of container cargoes after World War II, longshoremen alone kept commodities moving from hold to wharf and back again. Sheer muscle was the mainstay of most commodity transfer. Here dock workers unload sacks of taintor, a kind of chalk powder, from a berthed canal boat near the Michigan Avenue Bridge.

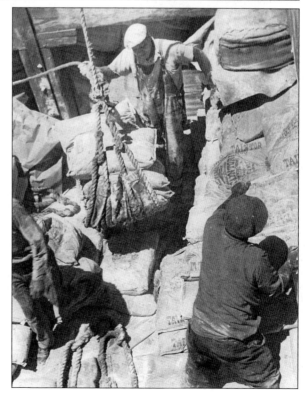

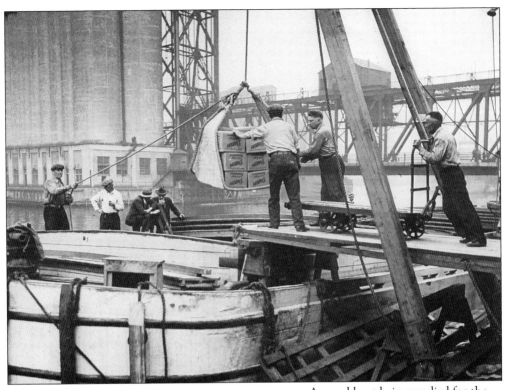

A canal boat being readied for the 1934 navigation season received a cargo of Domino sugar at the wharf just upriver of the Michigan Avenue Bridge. Domino was not manufactured in Buffalo but was shipped to diverse markets after passing through the city, making Buffalo's port facilities as important for transshipping package freight as bulk cargoes.

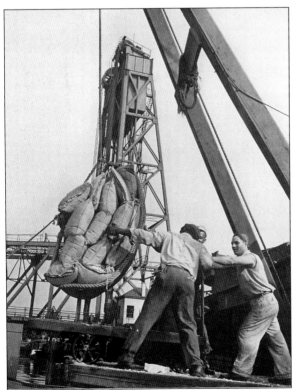

Longshoremen handled package freight in Buffalo. The men here in July 1937 were unloading cargoes with nets and cranes at the Minnesota-Atlantic Terminal adjacent to the Michigan Avenue Bridge. It was hot, hard work but welcome employment in 1937 because increased shipping marked a major upturn from the Depression. Longshore work was integrated, with African Americans playing an important role in Buffalo's waterfront economy.

Three

Waterfront Industries

Buffalo's commercial prominence during the first half of the nineteenth century was followed by equal success in manufacturing. The same benefits provided to Queen City commerce by its location at the intersection of key waterways spurred the development of numerous industries, including grain milling, metals manufacture, and a wide range of capital and consumer trades. The proximity of the Marine Elevator on the left and of the Union Furnaces on the right shows clearly the close relationship between commerce and industry on the Buffalo waterways.

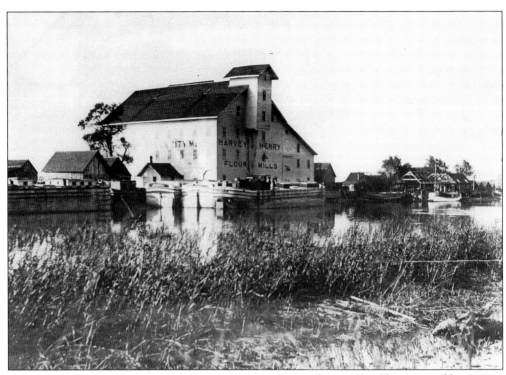

Queen City Flour, owned by Horace D. Harvey and J.F. Henry, operated on Squaw Island along the Black Rock Canal. The partners helped transform flour milling by introducing steel rollers in the 1880s, thereby making the city's mills extremely efficient. Queen City, built in 1837, operated until the late 1890s and then burned along with its neighbors, the Ryan and the Frontier, on June 18, 1901.

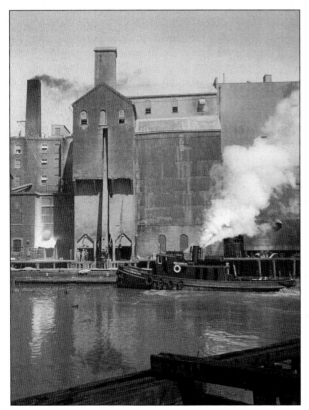

The Buffalo River gave rise to larger mills. The milling firm of Thornton & Chester had several mills, such as the National, on Buffalo's waterways. Mills combined the unloading and storage processes of elevators with internal transfers to move grain laterally to the processing areas. Flour and cereals, unlike raw grain, were highly perishable, and East Coast markets eagerly absorbed fresh supplies from Buffalo.

As with the grain trade, milling interests from outside Buffalo began to seek locations within the city. These new interests could receive ample Midwestern grain supplies and deliver large amounts of finished products to Eastern markets all within a single location. This is the Minneapolis-based Washburn-Crosby Mill A, built in 1903. Washburn-Crosby was the predecessor of General Mills.

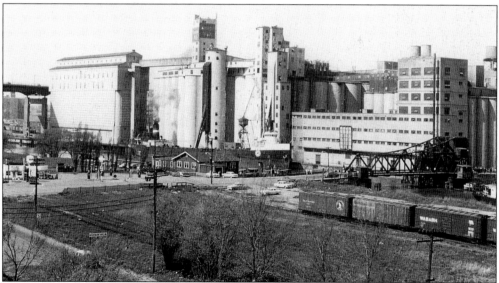

This is a view of the same plant in the 1950s. Washburn-Crosby and its successor company, General Mills, built several elevators on the City Ship Canal and expanded their milling facilities rapidly before and after World War II. The company operated both the Frontier and the Dakota Elevators as well as their original tile-bin elevator that was part of the first milling operation.

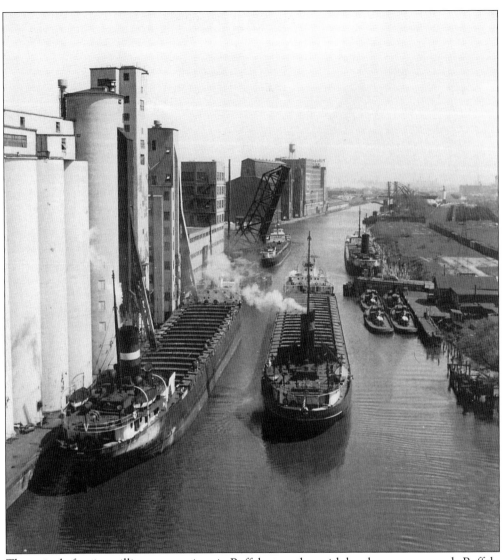

The arrival of major milling corporations in Buffalo, together with local processors, made Buffalo the leading flour milling center in America and a major cereal producer. In 1926 Buffalo was second only to Minneapolis in flour production, but four years later it had surpassed Minneapolis, a record held to the present day. Even as transfer elevator traffic diminished, the flour trade held steady. The demand for both brand name and merchant flours persisted unabated. The City Ship Canal has been home to two national flour and cereal producers, General Mills (left foreground) and Pillsbury (left rear). The latter acquired the Great Northern facilities in 1923. Other major flour producers included International Milling at the Lake & Rail Elevator, and Peavey, which acquired the American Elevator. These companies produced flours for both the baking industry and household consumption.

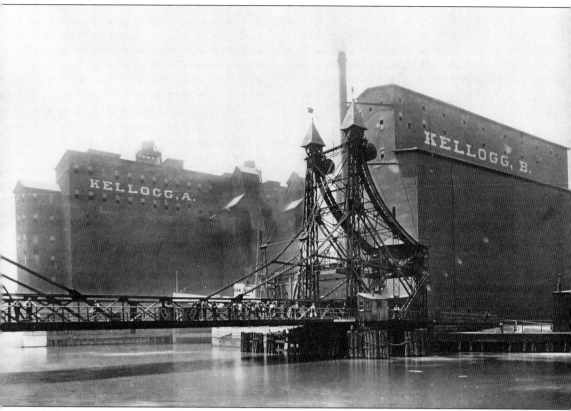

Buffalo's milling trade was not confined to flour, but included a wide range of capital products as well. The most successful firm was Spencer Kellogg Co., which produced vegetable oils used in paints, food processing, animal feed, and many other industries. The original wooden elevators, shown here alongside the ornate first Michigan Avenue Bridge, were replaced in 1912 with a concrete elevator, as the company expanded into a fully international operation. The firm operated in Europe, Latin America, and Asia until World War II, when many of the company's raw materials, such as castor beans and tung oil, were cut off due to wartime blockades. Nevertheless, the company persisted as a leading Buffalo industry until 1961, when it was taken over by Textron Inc., and local operations were closed..

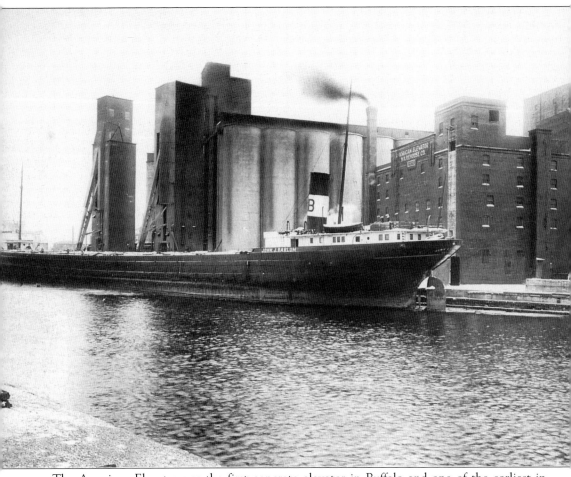

The American Elevator was the first concrete elevator in Buffalo and one of the earliest in America. It was built in 1906 for the huge U.S. trust, American Malting, founded in 1897 by grain speculators and bankers, including J.P. Morgan. The company settled on the Buffalo River to gain a Great Lakes toehold. The ship pictured here is unloading barley for the malting process used in Eastern beer making. The corporation drove several smaller Buffalo malt houses out of business but was itself finally obliterated by Prohibition. In 1921 Russell-Miller Co. installed a mill to produce its Occident-brand flour for Eastern markets. In the early 1950s R-M was acquired by Peavey Corp., the sixth largest grain dealer in the world. Peavey improved the elevator and made the mill the world's largest pneumatic flouring processor.

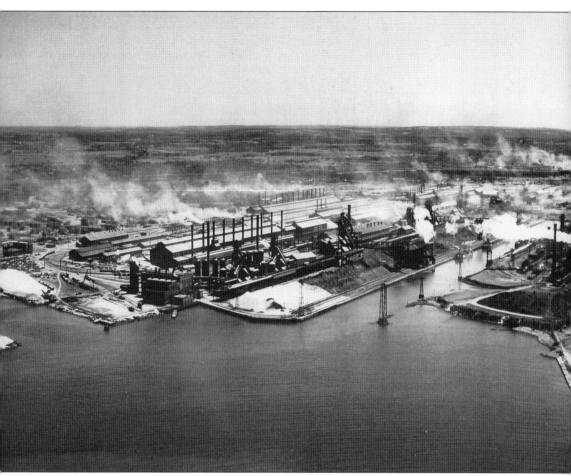

During 1899–1903, the Lackawanna Steel Company captured the imagination of the industry with a bold project to move its works from Scranton, Pennsylvania, to an undeveloped tract on the Lake Erie shore south of Buffalo. This decision reflected a major shift in the factors affecting the desirability of locations for steel plants. At sites on the Great Lakes, firms could economically assemble the raw materials required for steel making, including iron ore delivered by ship from new sources in Minnesota and Michigan. The renowned Mesabi Range had begun disgorging its glorious treasures in 1892. These new industrial conditions nourished the growth of steel plants in Buffalo, Cleveland, Detroit, and the Chicago area. The Lackawanna plant was organized around a large ship canal (right center) where the latest innovations in mechanical handling waited to unload incoming vessels delivering iron ore for the blast furnaces. Bethlehem Steel took over the Lackawanna plant in 1922. Waterborne deliveries of iron ore and taconite pellets to feed blast furnaces continued until steel making ceased in 1983.

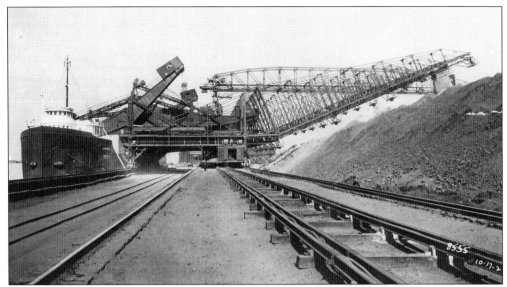

Hulett unloaders were the key to daily operations on the Lackawanna Steel Plant's ore dock for several decades. George M. Hulett of Cleveland, the center of ore-handling innovations, devised his unique machine in 1898, and it quickly became a familiar sight around the Great Lakes. This 1924 photograph shows the Lackawanna Huletts transferring iron ore from the vessel at the left to stockpiles in the ore yard at right.

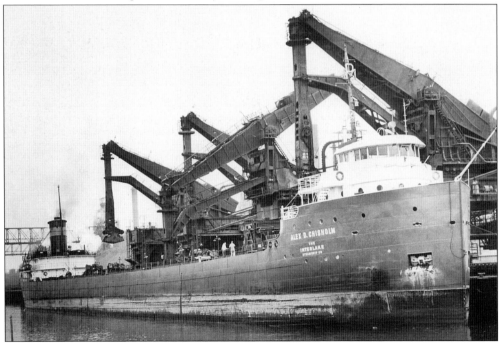

When this photograph was taken in 1959, the type of cargo being unloaded by the Lackawanna Huletts was beginning to change. Manufactured from low-grade, iron-bearing rocks, taconite pellets supplemented and then replaced depleted natural ores. The pellets handled more easily on conveyor hoists than did natural ores, so it was feasible to deliver them by self-unloaders. Eventually ore docks no longer needed Huletts, and most were scrapped.

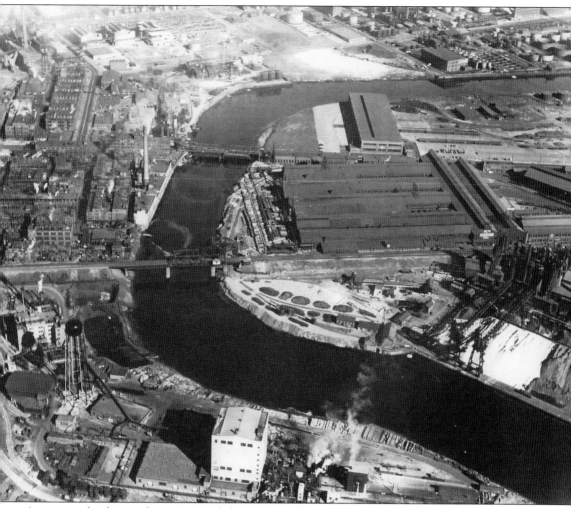

A variety of industries have occupied the upper reaches of the Buffalo River in the vicinity of South Park Avenue. At left in this view from the decade after World War II is the extensive Allied Chemical plant which, established by Jacob F. Schoellkopf, had originated as a manufacturer of coal-tar dyestuffs. At the top right, a portion of the Mobil Oil refinery is visible. In 1928 the fireboat *W.S. Grattan* was nearly destroyed in a waterfront holocaust on this stretch of the river. At center and lower right is the Republic Steel plant. New York State Steel had begun operations here in 1907. For the lake ore carriers negotiating the serpentine Buffalo River, the Republic ore dock acquired an unenviable reputation as a difficult site to access. As industrial effluents began to overwhelm the sluggish Buffalo River, several plants collaborated on a project to augment the abused stream's flow rate by blending in water pumped up from Lake Erie.

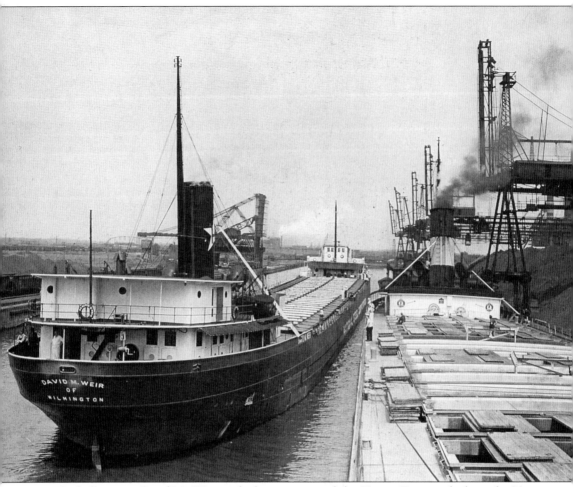

The bulk carrier *David M. Weir* worked its way toward the Hanna Furnace dock on the Union Ship Canal in 1957. The ship was one of several in the Great Lakes fleet of National Steel Corporation under the management of M.A. Hanna Co., based in Cleveland. Hanna Furnace at that time operated as the merchant pig iron division of National Steel, supplying material to the foundry industries for castings. The Brownhoist Bridge Tramways (right) patrolled the dockside, unloading boats arriving from the Upper Lakes and stockpiling their contents in the ore yard. This pattern of vertical integration in which a corporation owned raw material sources, transportation lines, and manufacturing facilities was common in the iron and steel industry. Hanna Furnace shared the Union Ship Canal, near the Buffalo-Lackawanna boundary, with the Pennsylvania Railroad's ore unloading facility. The railroad and the predecessors of Hanna Furnace had joined forces to excavate the canal during the early years of the twentieth century when Buffalo's manufacturing base was expanding rapidly due largely to its advantageous location on the nation's inland seas.

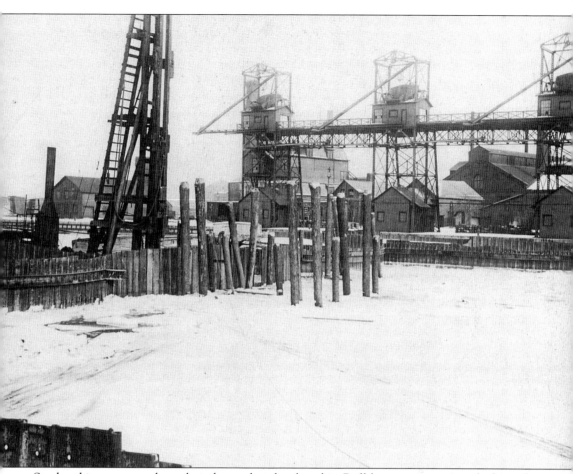

Steel making was not the only industry that developed in Buffalo to process minerals shipped down the lakes. The Buffalo Smelting Works grew directly out of the city's geographic position in relation to the natural resources of the upper Midwest. Maurice B. Patch, a mineralogist backed by Boston capital, perceived the cost economy inherent in transporting copper from the upper peninsula of Michigan by water. He set up works on the Niagara River in the Black Rock section to produce copper ingots, bars, and other semi-finished forms. The steamer *Linden* was built in 1895 to haul copper ore from Lake Linden on the Keeenaw Peninsula to Black Rock. This 1909 photograph reveals the elaborate materials handling equipment provided for unloading the copper boats. The pile driver in the foreground was being used for construction of the new U.S. ship lock near the plant. However, Buffalo's once-advantageous position was undermined as sources of Western and foreign copper surpassed the reserves of the Great Lakes region. The Buffalo Smelting Works petered out in the aftermath of the World War I.

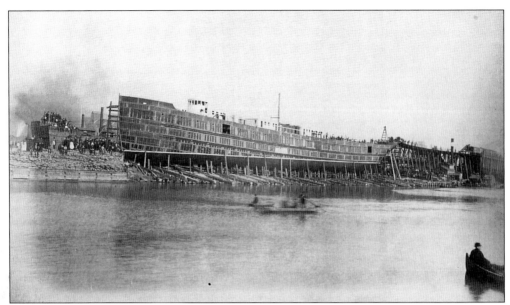

Amateur photographer Harlow Boyce brought his camera to the Union Dry Dock's shipyard in 1886 while the steamer *Susquehanna* was on the stocks. Union Dry Dock, organized in 1870, was affiliated with the Erie Railroad; it took over the business of the renowned shipbuilding firm Bidwell & Banta. During the early 1880s the new outfit began employing men who could build steel ships such as the *Susquehanna* in addition to wooden vessels.

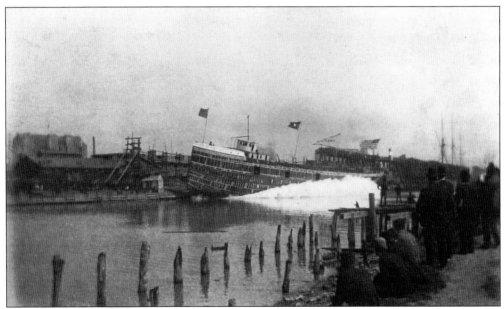

Harlow Boyce also photographed the launch of the steel steamship *America* on the City Ship Canal in 1889. Several years later Union Dry Dock joined forces with the adjoining shipyard of R. Mills & Co. The resulting Buffalo Dry Dock Company was swallowed up in 1900 by an even larger fish, American Shipbuilding, as part of the wave of consolidations that constituted the great merger movement.

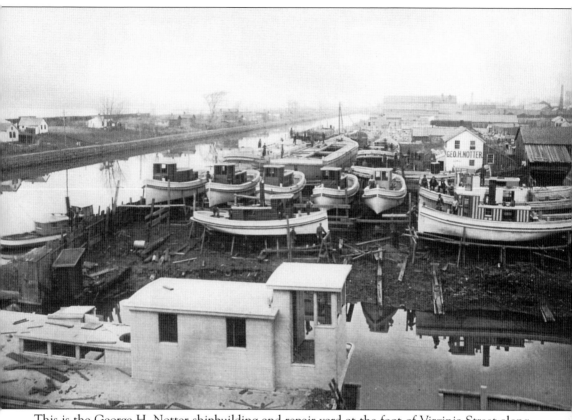

This is the George H. Notter shipbuilding and repair yard at the foot of Virginia Street along the Erie Canal. As early as 1875 Notter had produced six hundred tugs, another six hundred canal boats (including all of the steam-powered barges on the Erie Canal), five large propeller craft, seven large ships, as well as dredges, dump boats, and pleasure craft. The repair yard produced mostly wooden boats while his main facility off Austin Street made "the largest craft that run upon the lakes." He employed nearly three hundred men as carpenters, boilermakers, riveters, joiners, and the like who made all manner of wooden and iron vessels. Despite the company's early leadership within the Buffalo shipbuilding industry, by 1894 George H. Notter's yard was gone and his descendants, George E. and Thomas, were working for other firms as ship carpenters.

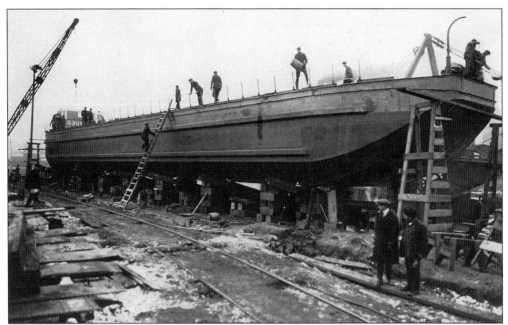

With the beginning of American involvement in World War I in 1917, Buffalo industries on the homefront joined in "to do their part." Ferguson's Shipyard broke ground on May 1, 1918, on a 7-acre site to produce steel navy vessels for the war effort. They were to be 151 feet long and of 1,000 tons capacity with 1,800 hp. engines and "from end to end will be Buffalo made."

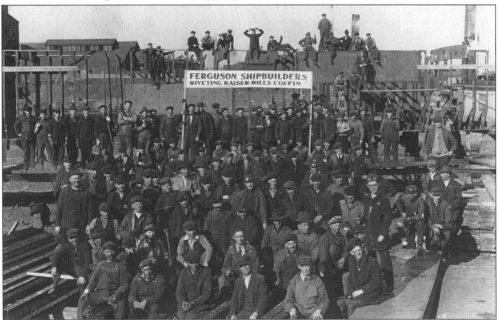

In 1913, as structural fabricators, Ferguson's had fifty employees; in wartime the company employed seven hundred and fifty hands. Edward P. Butts, the yard manager, had come from Curtiss Aeroplane Co.'s inspection department. He clearly fostered a unified commitment among the non-combatant employees, all older men and younger boys, to making defeat of Germany a major shipyard priority.

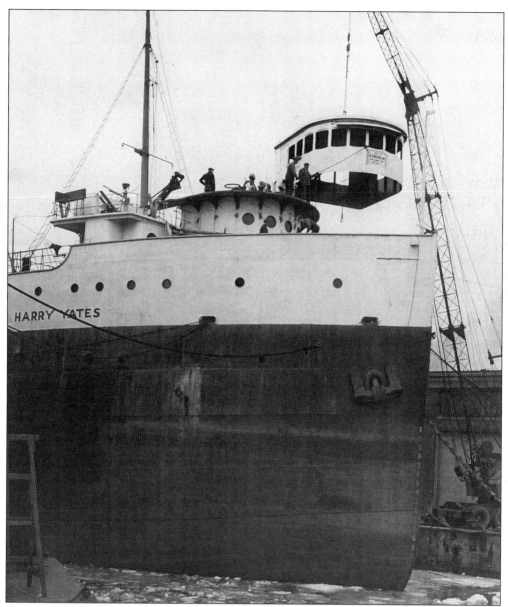

One of the most important waterfront industries was Oldman Boiler Works, located at 32 Illinois Street a block from the Buffalo River. Oldman founded the company as a general boiler fabricating and repair business in 1852 and then established its permanent site on the waterfront in 1907. As well as manufacturing boilers for the marine trade, founder William Oldman and successive generations of Oldman sons expanded the business by constructing smokestacks, pressure vessels for industry, and any manner of riveted or welded metal work of a large size. In the 1940s Oldman invented widely-adopted ship fairleads, pulleys permanently installed aboard ships to minimize wear on tie-down ropes. In addition to its manufacturing expertise, the company offered extensive marine repair work in its shop and on site. Here the *Harry Yates* of American Steamship is shown in March 1951 receiving a new pilothouse, which was fabricated by Oldman Boiler on Illinois Street and then transported to the foot of West Genesee Street, where Oldman's travelling welders installed the new parts.

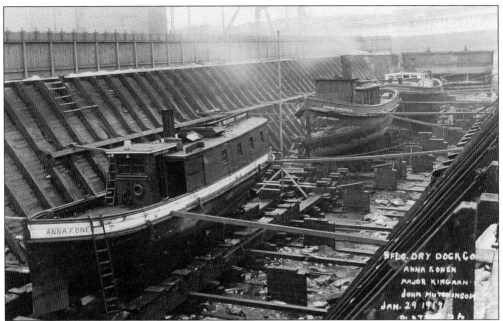

The workboat *Anna Onen* belonged to Marine Welding, an independent business in 1919 that was capitalizing on improvements in oxy-acetylene welding for use in ship repair. Owned by Charles Magee, it was a close ally of Oldman Boiler since the two did very similar work. In 1922 the two businesses merged as Oldman-Magee Corporation, but the partnership lasted only eight years. Marine Welding, like Oldman, was a leader in the movement away from riveting and to welding in the boiler fabricating and repair industry.

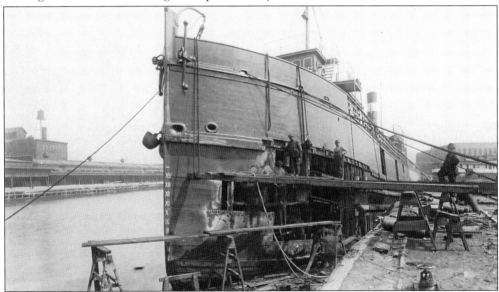

As a unit of American Shipbuilding, the Buffalo Dry Dock Company continued the long local tradition of maritime industry from 1900 until 1962. It specialized in repair work on the large number of vessels that wintered over every year after bad weather ended Great Lakes navigation. The Ganson Street facility closed because changing grain trade patterns cut the winter fleet while the parent company declined to invest in upgrading the yard.

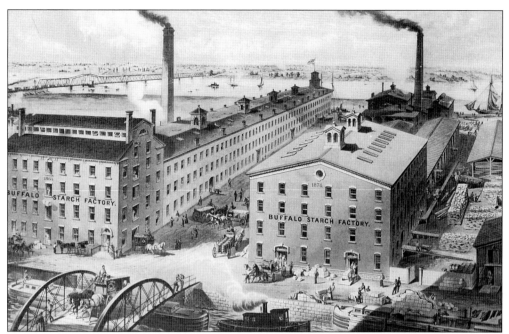

Buffalo's waterways spawned numerous small businesses for which water was both a part of production and a convenient mode of transport for raw and finished goods. Buffalo Starch Mfg. began in 1864; by 1877 the company achieved an international reputation for the high quality of its starch, which was made possible by the purity of Niagara River water. Later generations would regard pollution and production as synonymous.

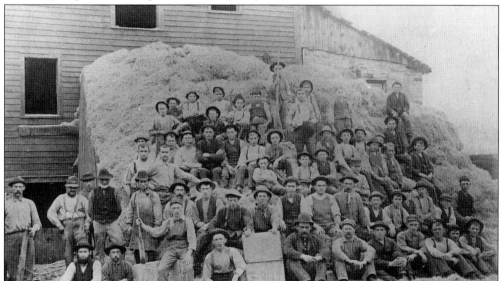

Nineteenth-century craftsmen were often posed climbing boldly upon the machinery they had made. Even so simple a business as lumber embraced that convention in this picture, which reflects pride in workmanship. These are the employees of J.S. Bliss, a Tonawanda shingle maker. Begun by J.A. Bliss in 1844, the business carried on after the owner's death in 1882 and by the 1890s was turning out 400,000 shingles a day, a significant accomplishment for these men and boys.

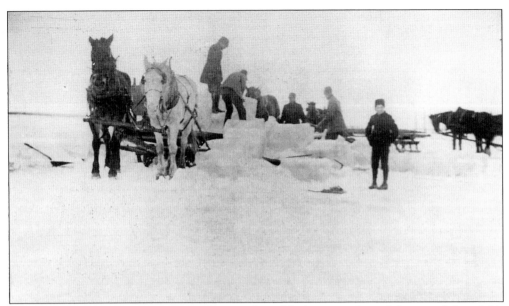

Ice cutting was an important industry. Ice was cleared by horses with steel drags, and then fields were laid out to get blocks of 32-by-22-inches, each weighing 200–300 pounds. Teams of men and boys cut the ice with saws, chiselblocks, and pike poles. Icehouses then accepted these seasonal "harvests" of up to 250,000 tons. In 1894 Buffalo had six commercial icehouses to provide ice blocks to homes and businesses, the only hedge against food spoilage.

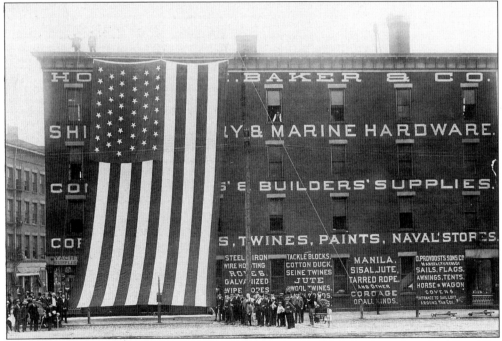

Howard Baker & Co., located at 18–26 Terrace, was Buffalo's leading ship chandler. The company provided all manner of goods detailed on the building to supply vessels in the harbor. It also manufactured flags and created this 30-by-50-foot example for presentation to the City of Buffalo on July 4, 1895, by some of Buffalo's leading citizens (including Baker himself).

Four

Life along the Water

Buffalo's waterfront attracted large numbers of people who lived both on and from the waterways. The crew of whaleback *Barge #103* were characteristic of the men who sailed the Great Lakes for a living. Away from home for weeks or months at a time, they were maritime nomads. Various professional and benevolent associations were organized on their behalf, such as Buffalo's Excelsior Marine Benevolent Association on Seneca Street.

The people who labored along the waterways were a devoted and loyal presence in Buffalo. Many lived in the First Ward, which abutted the Buffalo River, and it was from this area that most of the elevator crews, grain scoopers, and longshoremen came to their jobs—so did the "sidewalk superintendents" who engaged in the time-honored tradition of watching the other guy work.

"Politics on the Docks," by Harlow Boyce, reflects tensions over harbor working conditions. Jobs were dangerous; pay was low. Workers had little influence over their own affairs. In 1899 and 1900 scoopers held a strike against arbitrary pay methods and impositions of crew bosses. In 1906 dredge and tug workers fought for improved working conditions. Strikes were peaceful but gained little in non-union days.

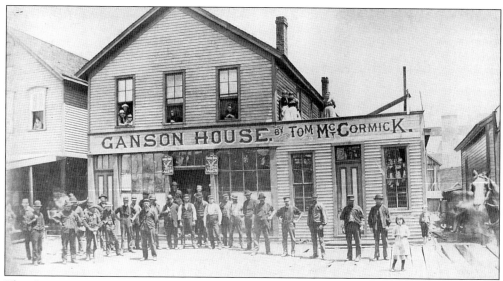

The Ganson House was a popular saloon on Ganson Street in the heart of the grain elevator district. Saloons on the waterfront played two roles: social center and hiring hall. The 1899 scoopers' strike was directed in part against saloon keepers' growing political power as boss shovelers with control over pay and conditions. The scoopers ironically found middle-class allies in their "temperance" movement, and the saloon bosses were defeated. Pay became hourly and crews picked their own leaders.

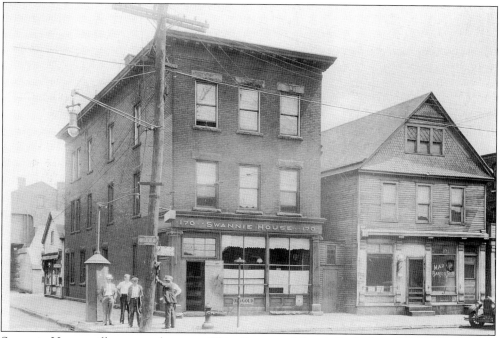

Swannie House still operates between Ohio Street and South Park along Michigan Avenue. In the 1890s when run by James Swannie, it functioned as a combined barbershop and saloon, thereby fulfilling two basic needs for its patrons. A companion business owned by other Swannie family members operated farther down the Outer Harbor at Tifft Farm and included a boarding house, presumably for seafarers.

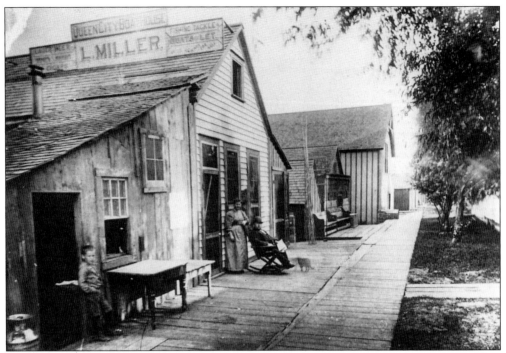

Queen City Boat House was a typical waterfront business. On Squaw Island between the Erie Canal and Niagara River, the Miller family worked and lived at this site. First Louis then Albert provided services to the marine trade, and Albert repaired boats for the Buffalo Yacht Club. On June 18, 1901, Queen City burned to the ground along with three flour mills. There is no record of its reopening.

Small commerce as well as large was a way of life in Buffalo on the waterfront. Casual markets sprang up when fishermen returned with their hauls and the small loads of goods were offered for sale. With no convenience stores, children such as these were sent to the docks at the foot of Amherst Street to buy the "necessaries" for the evening meal.

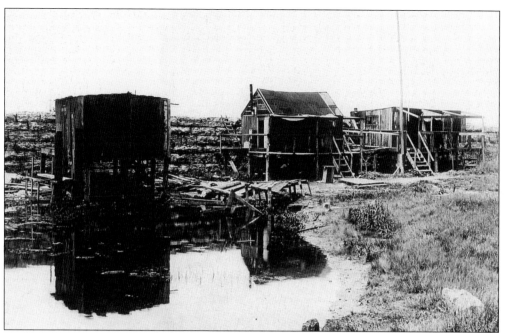

Much of the land along the early waterfront was unclaimed either as part of large land grants or parcels ignored by disinterested owners. In every quarter from the Old South Pier pictured here in 1914 to Squaw Island, both casual fishing "cottages" and more durable dwellings were erected by people who were technically squatters. Nevertheless, these settlements endured on the waterfront for decades.

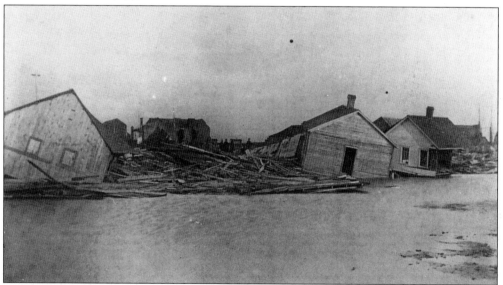

These waterfront communities were fragile. The land available for small cottagers trying to eke out a living around the water was undesirable. In 1844 a seiche wiped out much of the early community. In 1866 storms destroyed the unsubstantial dwellings; this happened again in October 1886, when winds gusted to 63 mph. Even normal weather patterns expended their initial fury on these plucky settlements. Nevertheless, the residents rebuilt when necessary and stayed.

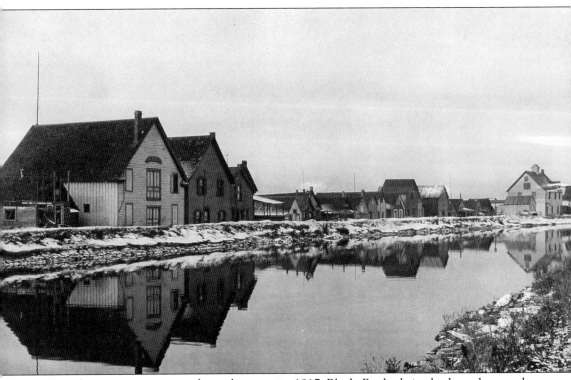

Waterfront communities such as this one in 1917 Black Rock thrived when the weather cooperated. From Breakwall to Squaw Island, along riverbank and towpath, small businesses grew, homes were built, families were raised, and a useful economy flourished. With the exception of Canal Town, which had a dark and unsavory history, these enclaves were reasonably stable and comparatively prosperous. The only thing that would eradicate them was progress.

Five

Construction and Maintenance

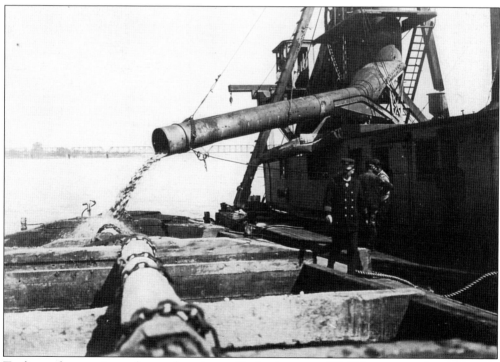

To digest the growing volume of marine traffic in the port of Buffalo, continual construction and maintenance of adequate harbor facilities were essential. Existing waterways had to be kept at navigable depth so vessels would not run aground, as this 1902 photograph of dredging on the Niagara River indicates. Improved docks, locks, and navigational aids were also required. Some construction projects resulted in eradication of traditional waterside communities.

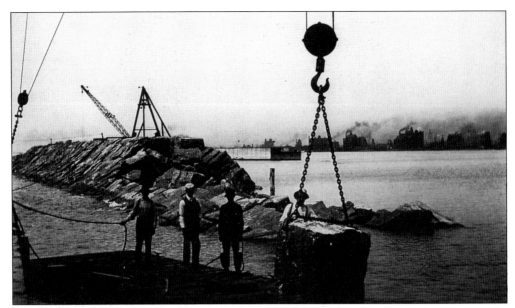

The series of offshore breakwaters in the Outer Harbor enclosed a sheltered anchorage for vessels and protected shoreline property from lake storms. The structures performing this double duty included the Old Breakwater (1868–1893); South Breakwater (1897–1902); Stony Point Breakwater (1897–1899); and North Breakwater (1899–1902). This photograph shows work crews placing a massive revetment stone on the lake side of the South Breakwater in 1899.

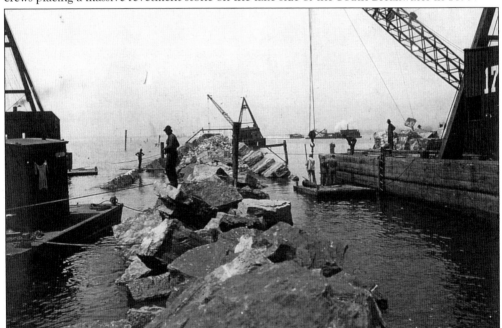

Major Thomas W. Symons of the U.S. Army Engineers was the guiding hand behind the rapid expansion of the breakwater system. He foresaw the works as "destined to give Buffalo a thoroughly protected outer harbor of noble proportions." The construction projects aided both general plans for waterfront development and specific private interests. The Stony Point Breakwater helped entice the Lackawanna Iron & Steel Company to relocate to Buffalo.

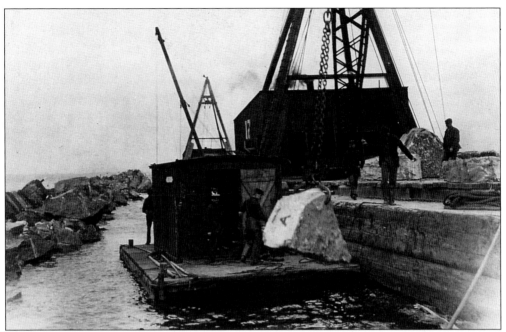

Several different construction techniques were used in building the Outer Harbor breakwaters. One method, shown here, involved laying down an underwater foundation composed of rubble stone with gravel hearting and then piling up a mound of rubble topped by cut revetments and cap stones. Other sections employed timber superstructures, but these materials succumbed to the fury of the elements. The North Breakwater featured a concrete superstructure.

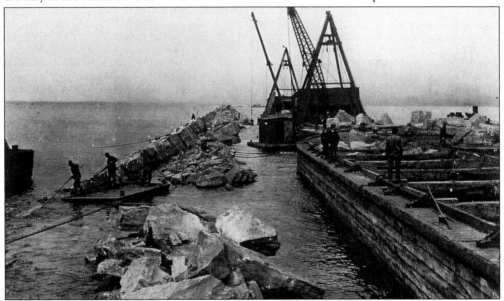

Working to build the breakwaters involved handling heavy materials in exposed conditions. Piles the length of telephone poles were driven to indicate the alignment of the structure and mark where materials were to be deposited. Scows carried stone to floating derricks. Construction crews pieced together the rubble mound designed to resist wind and wave. The crew went out on strike against the contractor, Hughes Bros. & Bangs of Syracuse, in 1900.

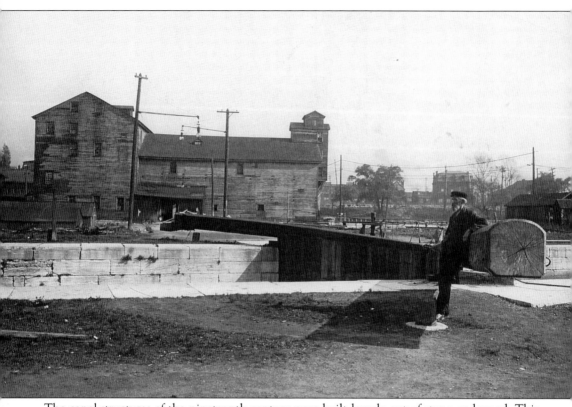

The canal structures of the nineteenth century were built largely out of stone and wood. This picture shows the ship lock that accommodated traffic between Black Rock Harbor, opposite the north end of Squaw Island, and the Niagara River. Visible are the large blocks of stone masonry, set in hydraulic cement, that formed the walls of the lock chamber as well as the wooden balance beams used for opening and closing gates. The rather ramshackle building in the background is the Erie Flour Mill, one of several in the vicinity that once operated by waterpower. Millers used the difference between the water levels of the Erie Canal and Black Rock Harbor to drive their machinery. The Erie Flour Mill was located between Amherst Street and the railway line to the International Bridge.

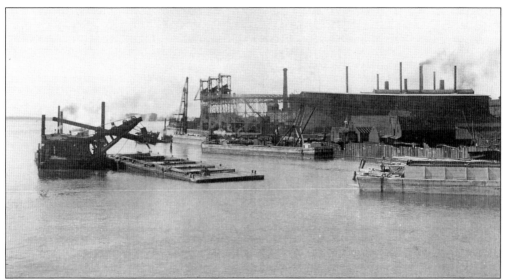

In 1909 the Army Corps of Engineers began building a larger U.S. lock at Black Rock, utilizing a different spectrum of construction materials and power sources. The new lock opened in August 1914. It was part of a project to bypass the shoals, rapids, and swift current of the Niagara River by means of the Black Rock Ship Canal; barge canal traffic also used this improved waterway, first proposed in 1904.

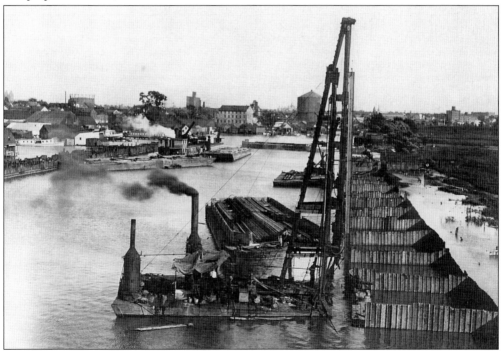

New materials used in the U.S. lock project at Black Rock included steel sheet piling from the Lackawanna plant, here being driven in place by a floating steam pile-driver whose upright boiler is belching smoke. The sheet piling formed part of a coffer dam which excluded water from the construction site. The coffer dam was proclaimed to be the largest of its type (947-by-260 feet) ever built up to that time.

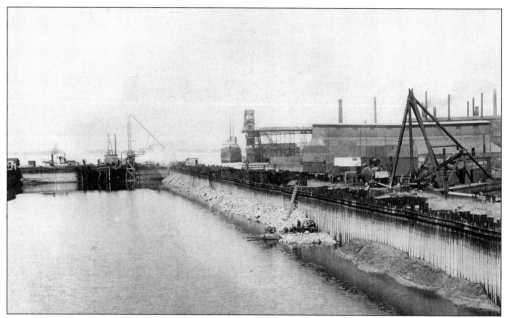

In this photograph the outline of the coffer dam is taking shape. Pumps are at work to control the water seeping into the construction area. The pumps had a daily capacity of 50 million gallons at lifts of 5 to 45 feet. The contractor for the lock was MacArthur Bros. Co. of New York City. The project forced pleasure boat owners and recreational clubs to relocate. Visible at right are the dock and plant of the Buffalo Smelting Works.

When the Black Rock Ship Lock opened for business in 1914, concrete had replaced stone as the principal material in the chamber walls, while electric motors opened and closed the large steel gates. The lock was constructed directly on bedrock consisting of limestone and dolomite interspersed with gypsum. Over the years hydrostatic pressure washed away the gypsum, causing leaks. Repairs involved pouring concrete grout into deep drill holes.

In conjunction with the construction of the Barge Canal, the State of New York undertook renovation of the deteriorated area around Erie Basin. A government photographer took this view of "wrecks north of Middle Pier, east from seawall" on April 18, 1914. The Exchange Elevator occupies the center of the picture. Shown at right is floating equipment used by Great Lakes Dredge & Dock Company for uprooting pilings.

The timber cribs used in the reconstruction of Erie Basin were framed and launched from this site near the Philadelphia & Reading Railroad coal trestle. The photographer is standing up on the trestle facing southeast toward the former site of the Erie Basin Elevator. The Erie Canal ran in front of the lumberyard at left.

The contractors responsible for renovating and reconfiguring the canal boat harbor at Erie Basin required shoreside facilities as well as floating equipment. This April 18, 1914 photograph shows the planing mill of the McNeil Lumber Company, situated at the north end of the yard occupied by Great Lakes Dredge & Dock.

This picture was taken by the New York State Engineer's western division office on the same date as the view above. It shows the oil house and tool shop of Great Lakes Dredge & Dock on the north side of West Genesee Street in the vicinity of Erie Basin.

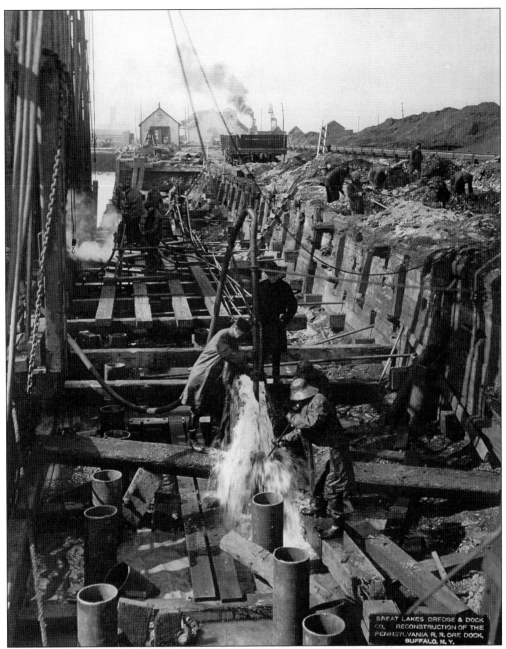

GREAT LAKES DREDGE & DOCK
CO. RECONSTRUCTION OF THE
PENNSYLVANIA R. R. ORE DOCK,
BUFFALO, N. Y.

On March 21, 1917, crews from Great Lakes Dredge & Dock were hard at work on the reconstruction of the Pennsylvania Railroad's ore dock at the Union Ship Canal. The following year, Great Lakes Dredge & Dock was engaged in a similar project, rebuilding the Buffalo River ore dock of the Donner Steel Company, previously New York State Steel, and subsequently the Republic Steel plant. As was the case with shipbuilders, tug lines, and other regional maritime businesses, Great Lakes Dredge & Dock represented an amalgamation of previously independent operators. By the mid-1920s, the Buffalo office was one of eight divisions on the lakes and the Atlantic coast. The company conducted its local projects from its plant at the foot of Katherine Street, which included a repair yard for maintenance of its equipment.

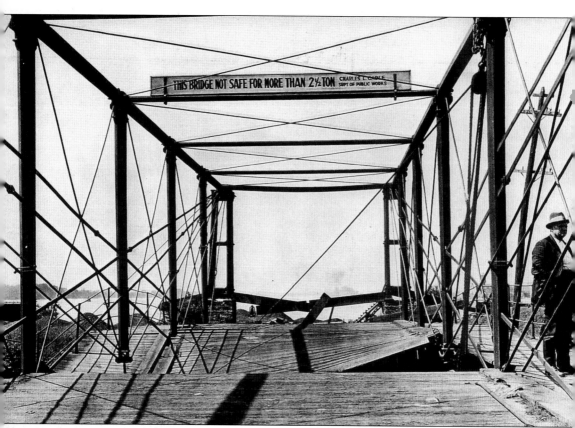

Time takes its toll even on historic infrastructure. This July 6, 1923 photograph shows the sad condition of the Bouck Street Bridge over a disused Erie Canal section in Tonawanda. The decaying iron bridge was an eccentric example of a truss design patented in 1852 by the Baltimore & Ohio railroad engineer Wendel Bollman. Many other interesting bridges once traversed the enlarged Erie Canal along its route across the state, including the bowstring trusses devised by New York engineer Squire Whipple. Canal bridges were once common engineering features of urban, village, and rural landscapes that have since passed from view. They are being followed into oblivion by a later generation of metal truss bridges over the Barge Canal. The engineer George W. Rafter had championed high, fixed bridges with long approaches for canal crossings in the late nineteenth century. These landmarks are now falling victim to unsympathetic highway modernization programs.

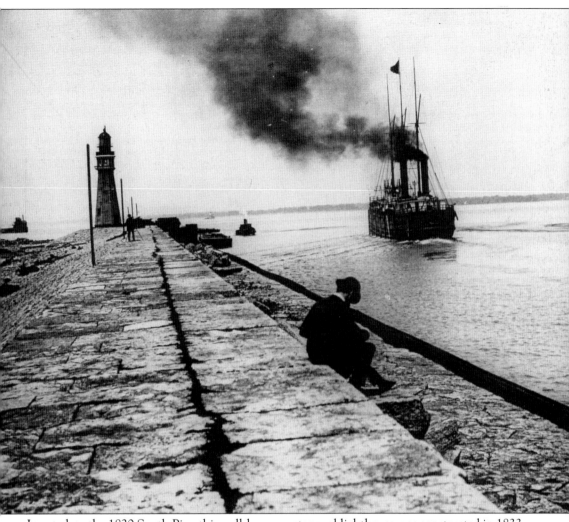

Located on the 1820 South Pier, this well-known octagonal lighthouse was constructed in 1833 at the mouth of the Inner Harbor. Made of smooth-faced limestone ashlar, it was topped by an ornate cast-iron lantern and weather vane. The light stands 76 feet above water level and is 20 feet in diameter at the base and 12 feet at the top. The nickname "Chinaman's Light" was garnered by its vaguely pagoda-style appearance. Folklore also claims it was a lookout for illegal Chinese immigrants. In 1844 the tower was seriously damaged in a storm, and then the light was refitted with a much-improved dioptric Fresnel lens in 1857. Following these alterations, the light operated until World War I, when it was finally replaced. It continued as a lookout post until 1937, when it was closed completely. In 1961 rumors of demolition galvanized preservationists, and the light was rescued and restored by the Buffalo and Erie County Historical Society. It is now maintained by the Buffalo Lighthouse Association.

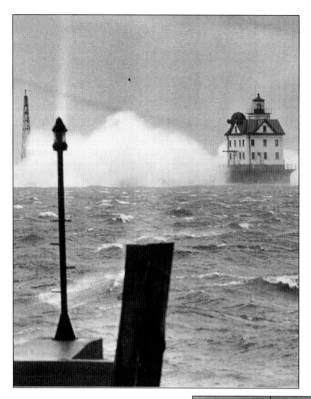

The Buffalo Light, one of a series of lighthouses that dotted the waterfront over the decades, was built in 1914, and it replaced the 1833 light. As part of the Coast Guard lighthouse service for the Buffalo Harbor, its million-candlepower light was visible for 16 miles and its diaphone warning call could be heard 14 miles away.

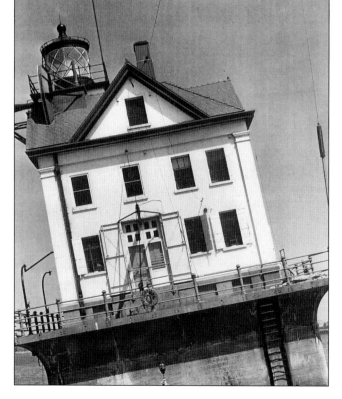

On July 28, 1958, the *Frontenac* was departing Buffalo after delivering ore to Wickwire Spencer down the Black Rock Canal. Headed for Marquette, Michigan, the *Frontenac* needed a sharp turn to clear the Breakwall, but its anchor failed to catch on the bottom. Its too-wide arc caused it to hit the structure, and the "Leaning Lighthouse" was knocked 15 degrees off center. Although it still worked, it was demolished in 1961.

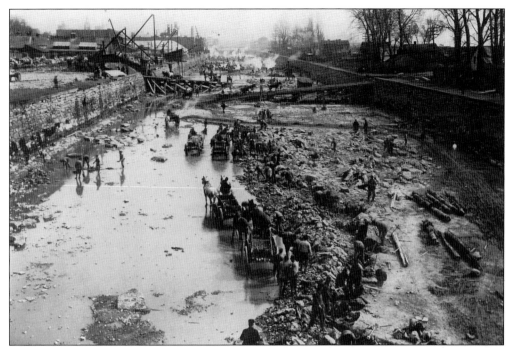

In 1896 New York embarked on its final effort to improve the capacity of the Erie Canal. The strategy involved deepening the canal prism by excavating the bottom or raising the banks. This method of increasing the cross-section of the waterway and the size of canal boats had been elected over an alternative that recommended increasing the speed of existing vessels through improved propulsion methods such as electricity.

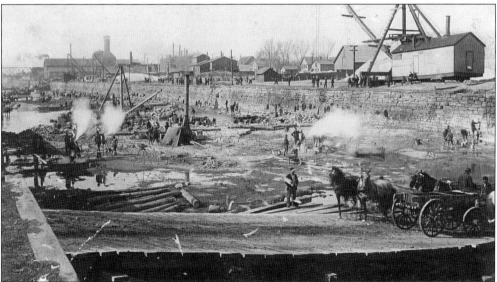

The 1896 program to deepen the Erie Canal fizzled out in two years. Emphasis shifted to planning for a new Barge Canal capable of accommodating larger boats. Earlier in the decade, however, portions of the canal between Erie Basin and Black Rock had been enlarged by subaqueous rock excavation. Canal reconstruction during this period proceeded in conjunction with attempts to mitigate municipal sewerage discharges into the waterway.

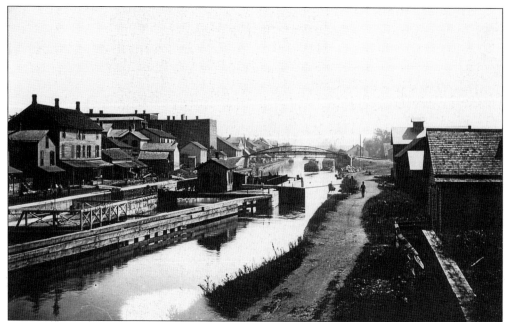

The opening of the Barge Canal in 1918 by-passed the Buffalo section of the Erie Canal, which lost its economic focus in supporting water-based commerce. Despite this change, towpath communities such as this one beside Lock #72 endured for many years. The canal became widely used for recreation, and people from all over Buffalo used the area for fishing, cycling, and boating.

At the turn of the century, waterfront communities near city center were eradicated by unfair competition. Land-hungry railroads forced settlers out by sending trains through narrow rail passes with poles strapped to the sides to shove fragile cottages off their bases. Settlements farther north on the towpath between Carolina and Porter, with sites leased at $3–$5 per month from the City, were ordered out in May 1938, this time in the name of "beautification."

In April 1957 the State Department of Public Works finally condemned all towpath land for the proposed Niagara Thruway. Although much of the southern Erie Canal had already been filled, settlements such as "The Marsh," the area between Riverside Park and Sheridan Drive, persisted. It was so stable that residents held honorary mayoral elections at Frank Mutz's tavern. The condemnation order was received as a total betrayal.

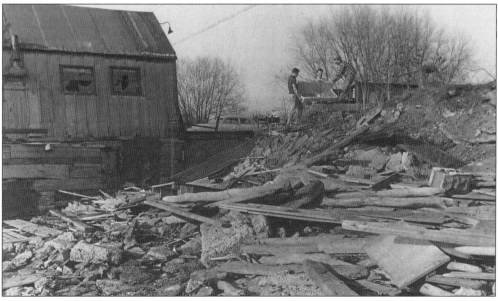

The towpath had been home to dozens of recreational organizations. The Oak Tree Fishing Club, Riverside Hunting and Fishing Club, Turkey Point Club, Parkside Wheeling Club, and 1903 George Washington Fishing and Camping Club all maintained clubhouses alongside homes. As the bulldozers moved in, people struggled to salvage whatever they could.

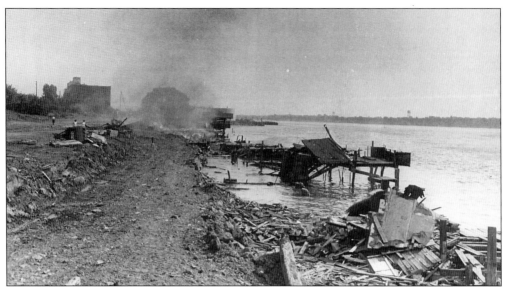

The 1957 condemnation order proceeded quickly. What had once been a flourishing residential and economic community was first bulldozed and then burned to make way for construction of the I-190 Niagara Thruway. Waterfront access, once taken for granted, was also eradicated. The fenced-off concrete ribbon of highway replaced the canal waters and prevented convenient passage to the Niagara River as well.

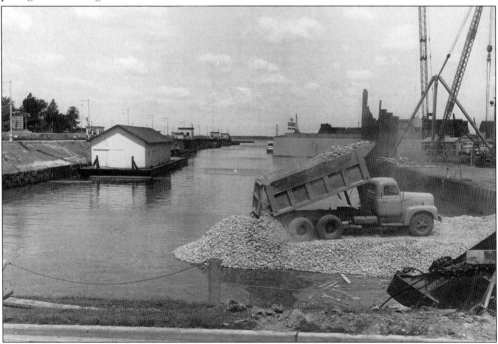

The final fill of the canal to make a roadbed for the Thruway totally altered the waterfront along the Niagara River. Water views for remaining homes were largely eliminated, and recreational uses of the river along the Riverside and Black Rock areas were greatly reduced. River access was restricted for boating and fishing, and simply strolling along the water was no longer possible.

Six

Workhorses

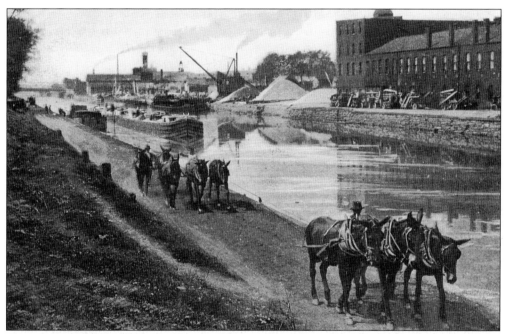

The original workhorses on the Erie Canal weren't horses at all but mules. Mules, the offspring of donkeys and mares, were more surefooted and thus safer working along narrow towpaths. This picture illustrates the typical barge-towing conditions along the Buffalo section of the canal. Taken in 1912, the photograph shows teams as they work the stretch between Hudson and Genesee Streets. On this leg of the journey, the canal turned south and followed the course of the Niagara River with the same down-sloping pull toward the falls. Both of a canal boat's mule teams were needed to haul the heavily-loaded boats.

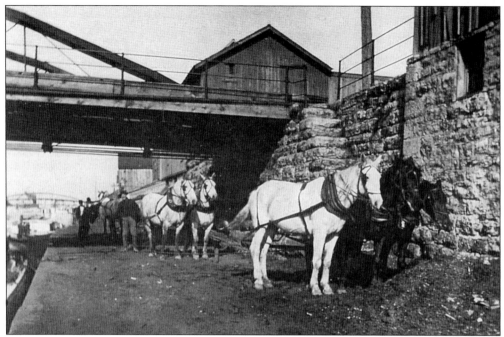

Two teams of animals worked each boat. They were housed and fed in the "bowstable" at the front on the boat and changed places every six or seven hours along with the drivers. When boats reached Buffalo, owners had the option of boarding their animals during layover and loading periods at the canal stables of James Delahunt at 61 Lloyd Street.

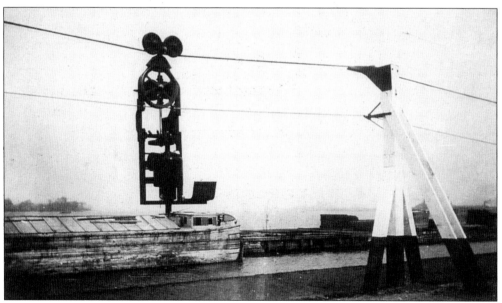

Buffalo's historic entry into electrical generation began with the first power transmission in December 1896. Not long thereafter, innovative applications of electricity for every conceivable problem were introduced. The "Iron Mule," pictured here *c.* 1898, was a large hook suspended along overhead power lines. It was proposed as an alternative to real mules, but the iron version proved unworkable and was soon abandoned.

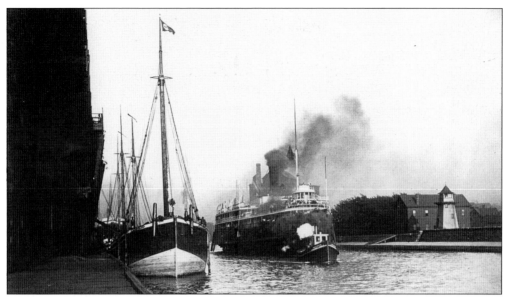

Tugs were essential workhorses on the waterfront. They were responsible for moving unpowered craft and assisting larger vessels to maneuver in confined areas. The first steam tug in Buffalo made its appearance in 1855; called the *Franklin*, it had been purchased at Albany by William Farrell. This early-twentieth-century view shows one of the *Franklin's* offspring escorting an overnight passenger steamer out the mouth of the Buffalo River.

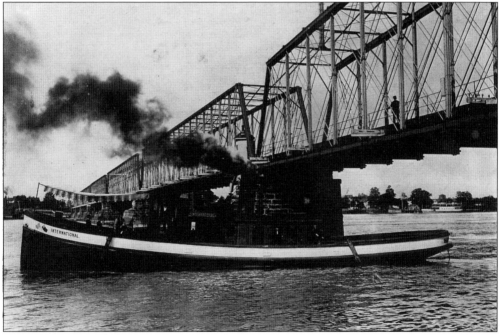

Shown here beneath the International Bridge over the Niagara River, the tug *International*, built in 1884, was also owned by the bridge company. One local author recalled the *International*, "which would meet [lumber] tows as they entered the River from Lake Erie, throw a line to the stern of the last barge, and, like a sea anchor, keep the nautical procession properly aimed for the swing opening of the bridge."

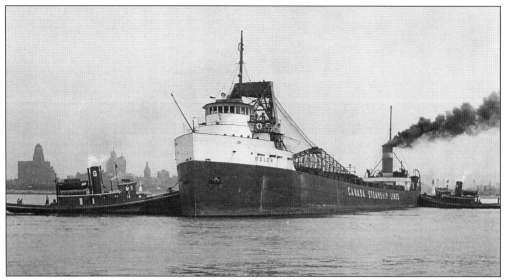

Early in the morning of August 23, 1944, the Canadian self-unloader *Osler* ran aground on its way from Buffalo to Toronto loaded with 7,600 tons of coal. The *Osler* had to unload most of its own cargo into another bulk freighter pulled alongside, and then maneuver free of the sandbar with the aid of two Great Lakes Towing tugs, the *Colorado* and the *Maryland*.

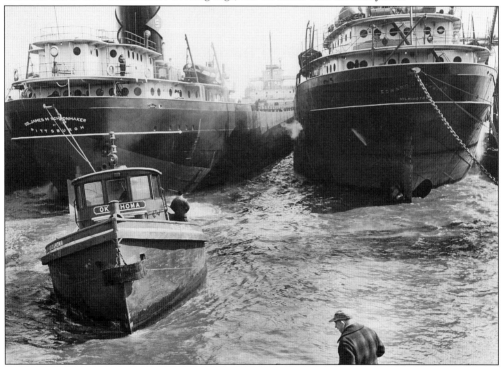

Tug *Oklahoma* pulls *James M. Schoonmaker* from its Union Ship Canal winter berth at the opening of the 1956 navigation season. The *Schoonmaker* proceeded to the Breakwall, where it awaited the go-ahead to enter the lake. Because of the Buffalo River's serpentine configuration, tugs have often towed ships backwards to eliminate the nuisance of going upriver to the turning basin solely to leave Buffalo bow first.

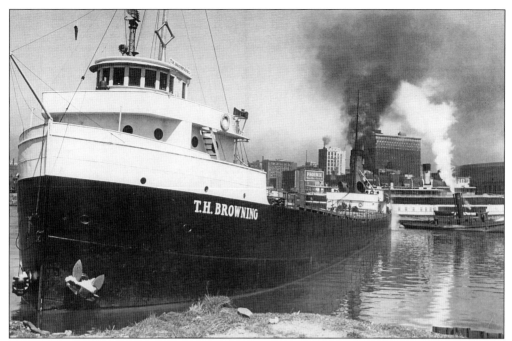

A tug from the Great Lakes Towing fleet has a line on the stern of a limestone carrier. With its bow nearly up on shore, the vessel is being turned prior to being towed upstream. This picture was taken in 1951. In later years some parsimonious vessel owners have attempted to dispense with the services of tugs by winching their ships ashore and turning them about unaided.

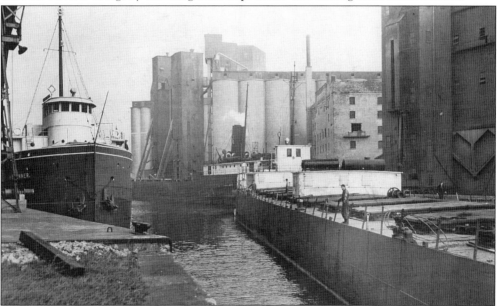

The November 1941 tug strike underscored the vessels' importance to lake commerce. Freighters such as these at Standard Elevator had to move on their own but lost many hours trying to negotiate the river's turns. A minor collision occurred between *David Z. Norton* and *J.M. Davis*, but little damaged ensued. The strike ended quickly, and tugs once again cleared the traffic in the Inner and Outer Harbors.

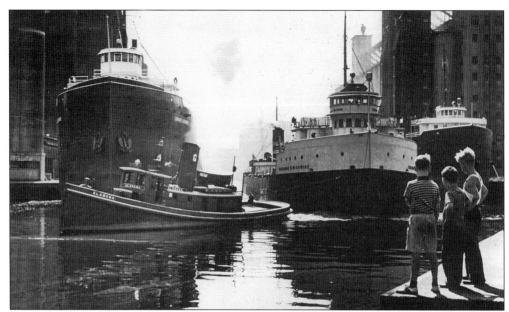

Watching the intricate ballet of tugs and their tows provided an endless source of free entertainment for spectators entranced by routine port operations. In this 1939 photograph, boys at the foot of Hamburg Street in the Old First Ward observed the tug *Alabama* and steamer *Theodore H. Wickwire* heading upstream on the Buffalo River. The vessels are about to make a sharp right turn at the Lake & Rail Elevator.

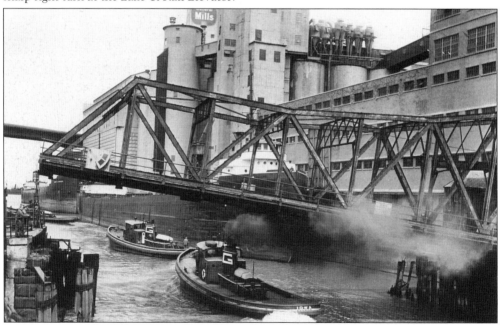

Tug crews formed a skilled team whose unpublicized labors kept the busy harbor in business. Here the *Iowa* and other tugs prepare to shift two lakers at the Dakota and Frontier Elevators in 1959. The Great Lakes Towing firm, whose insignia appears on the tugs' stacks, had previously established itself as the successor to such nineteenth-century outfits as the Hand Line and Thomas Maytham's fleet.

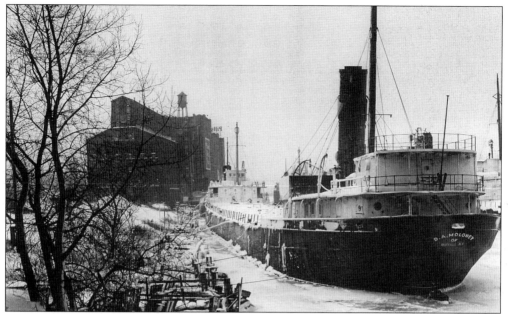

Since Buffalo was a major Great Lakes port, ships from many locations laid over on the city's waterways during the winter season when navigation was impossible. The safest location for winter tie-downs was the City Ship Canal, shown here with the *D.A. Moloney* moored in front of General Mills and Pillsbury. The absence of current in the canal allowed ships to be moored by ropes alone and protected them from damaging ice floes and debris.

Winter tie-downs along the Buffalo River were more complicated than those in the City Ship Canal. Even when frozen, the river maintained a current, and if ice blocks broke, the river's speed was hazardous to craft berthed along the river's banks. Chaining the fleets for winter was the responsibility of each ship's crew, some of whom are shown here making diligent preparations at the end of the navigation season.

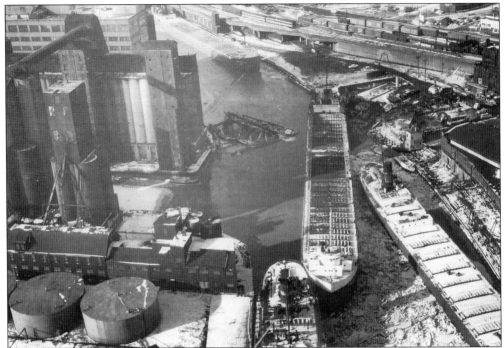

Shortly before midnight on January 21, 1959, first the *MacGilvray Shiras* and then the *Michael K. Tewksbury* broke loose from their winter moorings and began an infamous joyride down an ice-jammed, water-swollen Buffalo River.

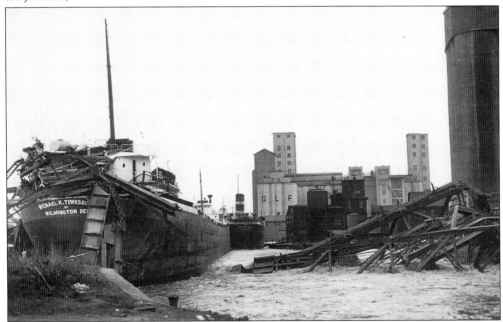

The *Shiras* came free and, unpiloted, navigated three right-angle turns before rounding the last bend and heading for Standard Milling where the *Tewksbury* was tethered. The *Shiras* collided with the *Tewksbury* at 11:08 pm, and together they hurtled further downriver, sterns first, toward the Michigan Avenue bridge.

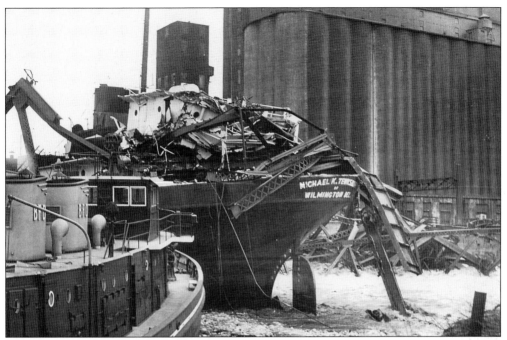

The bridge crew had little warning and were able to raise the span only 20 feet before the *Tewksbury* bore down and the three men, Casimir Szumlinski, Victor Winton, and William Mack, ran for their lives. When the *Tewksbury* hit, it toppled the bridge's South Tower, crushing the Connelly Ship Chandler Company and smashing the Engine 20 Firehouse, thereby trapping the fireboat *Cotter*.

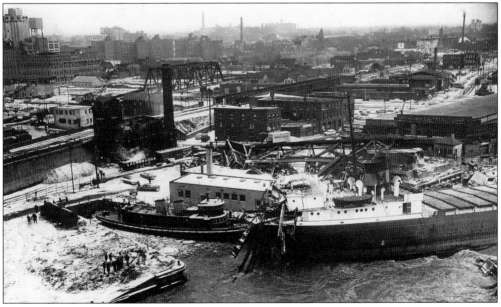

Amazingly, no one was seriously injured, but the river was completely blocked. Clean-up was immediate to prevent sending dammed-up water into South Buffalo. Bridge replacement was another priority; Ohio Street was closed for maintenance, leaving the Skyway as the sole route to the auto and steel plants. Damage ran in the millions.

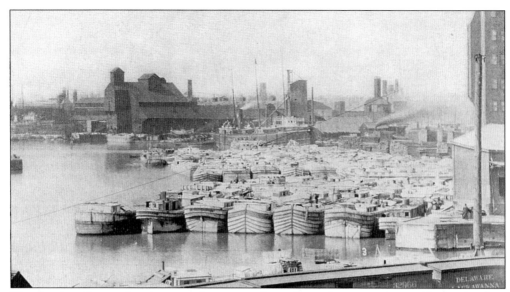

The floating pieces of equipment whose crews kept channels open to navigable depths were important cogs in waterfront operations. This photograph of Erie Basin during the abortive canal deepening project of 1896–1898 clearly indicates the liabilities of low water. Canal boats jammed to the docks between the Exchange Elevator (right) and the Erie Basin Elevator (left) because other portions of the anchorage were inaccessible due to silting and wrecks.

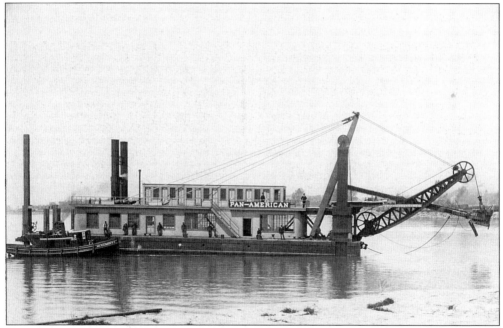

Some turn-of-the-century firms that engaged in channel maintenance also handled construction contracts. The Buffalo Dredging Company, for example, rebuilt the South Pier at the Buffalo River entry and fashioned the West Shore ore dock. The company also ventured into the field of environmental remediation to abate the public nuisance of the abandoned Main & Hamburg Canal. Other firms in the field included Dunbar & Sullivan, Lake Erie Dredging, and International Dredging.

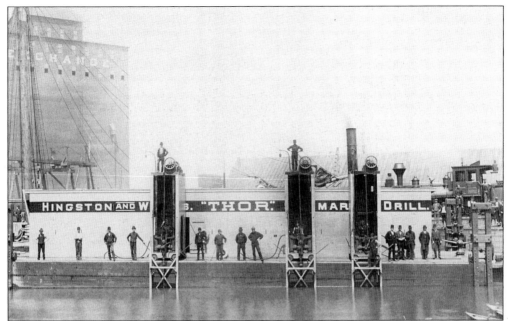

The drill boat *Thor* was the pride of dredging contractors Edward J. Hingston and Arthur Woods. Such craft were used in preparing holes for placement of underwater explosive charges. When construction on the Black Rock Canal and U.S. Lock commenced during the first decade of the twentieth century, floating rock cutters took over some of the duties previously performed by drill boats, the first such instances on the Great Lakes.

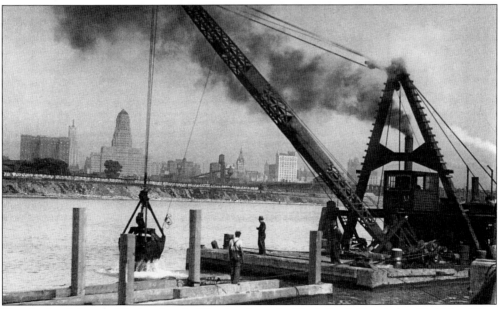

The dredge *Atlantean* lifts its clamshell bucket from the Black Rock Canal near Bird Island Pier in 1936. Dredgings were also used for building up new shoreline areas. In the background is Centennial Park (now LaSalle Park), a land reclamation project. Two years later the Depression-era WPA broke ground for a parkway alongside Centennial Park from the Marine Airport near the foot of Georgia Street north to Porter Avenue.

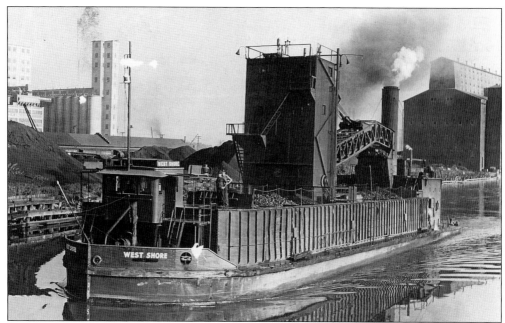

A floating lunch bucket for famished lake vessels, the fuel lighter *West Shore* steams north on the City Ship Canal. From 1910 until 1963 this ungainly little self-unloader ferried bunker coal from its namesake railroad yard to replenish ships throughout the harbor before they continued their journeys. This photograph dates from 1947. For part of its career, the *West Shore* was operated by the Pickands Mather Fuel Company of Cleveland.

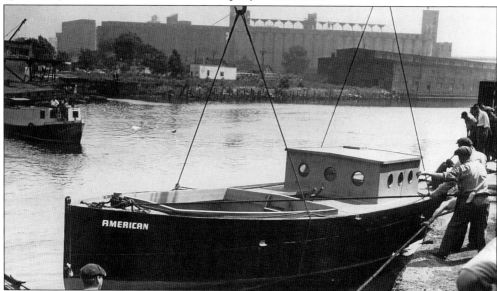

Smaller boats played important roles in the daily drama of ordinary port activities. In 1949 the service scow *American* joined the supporting cast as part of American Shipbuilding's improvement program at Buffalo Dry Dock. Ship chandlers and marine supply businesses, such as Connelly Brothers, employed launches known as bum boats for making deliveries to shipboard customers. The bum boats carried everything from rope, paint, and oil to groceries and laundry.

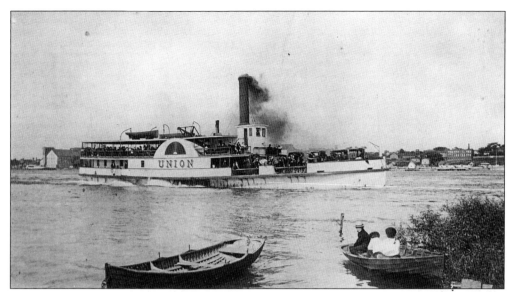

In the days before the Peace Bridge, ferries were the sole means of access to Canada. The sidewheeler *Union* pictured here carried passengers between Buffalo and Ft. Erie. A Canadian vessel, she was built in 1864 and rebuilt after a fire in 1865. In 1884 she was sold to local interests, and, as writer Stuart Wilkes recalls, she "wheezed across the Niagara River" for twenty-five years. She carried passengers plus carts and wagons for her seven-minute trip, doing her duty until she sank in the river in 1909.

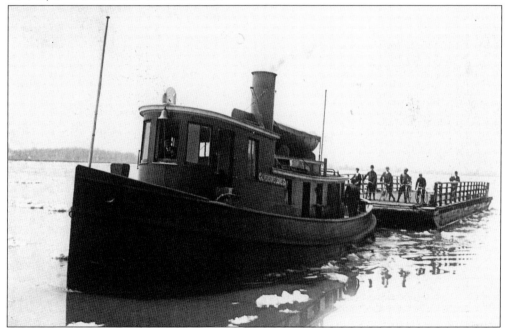

The Grand Island Ferry was at the opposite end of the spectrum from the *Union* and grand ladies of the lakes. Preceding the completion of the first set of Grand Island Bridges in the 1930s, this ferry was the sole access to and from the island. Highly utilitarian, this tug-and-scow arrangement seen here in 1915 could carry several autos as well as pedestrians or bicyclists even in heavy weather. What it lacked in amenities it made up for in practicality.

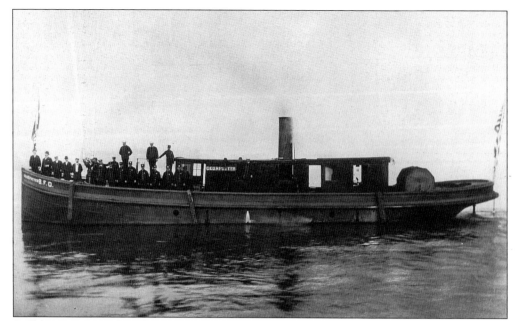

Buffalo's commercial and industrial waterfront constantly confronted the threat of fire. In 1887 the City's first fireboat, *Engine No. 20*, entered service; it was subsequently known as the *George R. Potter*. The following year the *Potter* battled its first blaze, caused by a steam pipe explosion at the Haines Lumber Yard. The *Potter*'s crew consisted of a foreman, an assistant foreman, two engineers, and four firemen. In 1893 a waterfront firehouse opened to accommodate a second fire tug, the *John M. Hutchinson*.

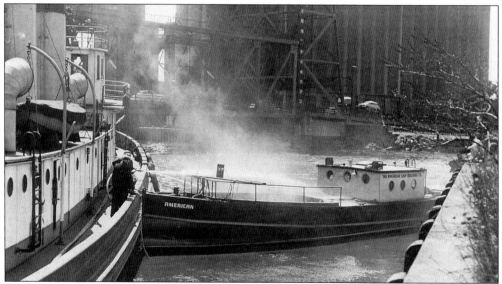

Dousing a smoky outbreak aboard the service scow *American* in 1953 hardly tested the capabilities of Buffalo's most famous floating fire engine, the *W.S. Grattan*. Named for a railroad construction contractor and City fire commissioner, the *Grattan* arrived from a New Jersey shipyard in 1900. On March 22, 1901, the *Grattan* responded to a major fire at American Shipbuilding's Buffalo Dry Dock that engulfed the woodworking shops and lumber storage areas.

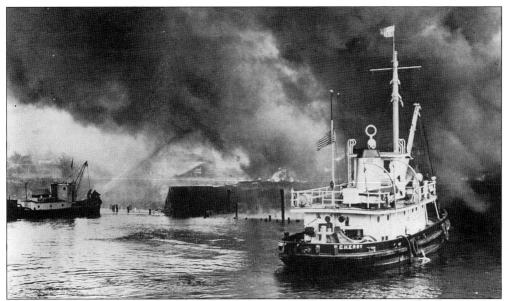

The list of fires fought by the *W.S. Grattan* read like a chronicle of major waterfront disasters: the Husted Mill in 1913; the General Mills Cereal Plant in 1940; the 1951 collision between the gasoline barge *Morania* and the lake freighter *Penobscot*; and the 1972 explosion and fire at the Pillsbury Flour Mill on the City Ship Canal. In this photograph, the U.S. Coast Guard's *Cherry* pitches in to help battle the Dold Feed Mill fire.

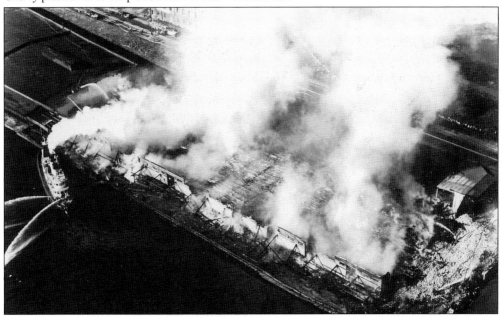

The *Grattan's* water cannons commenced firing at the Erie Warehouse fire in 1949. Rebuilt after a 1928 waterfront catastrophe and modernized in 1953, the vessel was renamed in honor of Edward M. Cotter, president of Buffalo Fire Fighters' Local #282. In 1960 the *Cotter* lent unprecedented assistance in the Port Colborne, Ontario, Maple Leaf Mills fire. In semi-retirement, it gained further distinction upon being designated a National Historic Landmark in 1996.

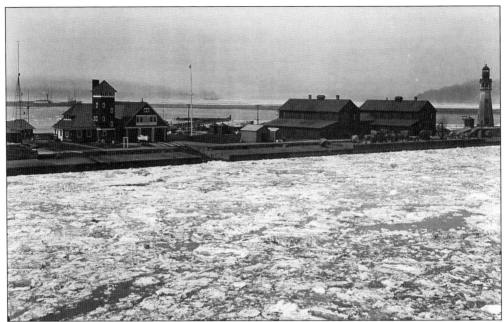

With frequent shipwrecks on the Great Lakes and the growing popularity of water sports, a lifesaving service began in 1877. Two years later it established quarters on the lighthouse pier. It was insufficient for many Buffalo residents, and in 1902 they established a Volunteer Life Saving Service with participants trained in rescue and resuscitation. In 1903 the new lifesaving station was opened in August.

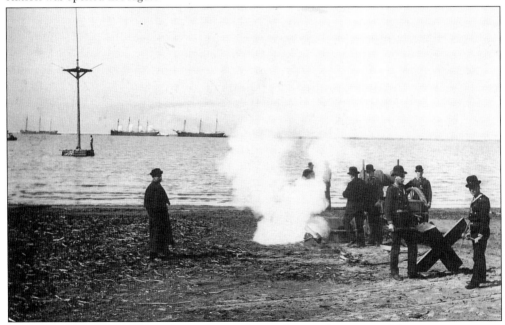

An important part of rescue work was ship-to-ship or ship-to-shore rescue. Victims in a capsizing vessel were placed in a breeches buoy and pulled over water to a safe haven. In order to rig the buoy, rescue crews fired the Lyel gun to carry the initial tie-down rope to the distressed ship. Here rescue crews practice the maneuver with a mock-up of a sinking ship.

Seven

Recreation

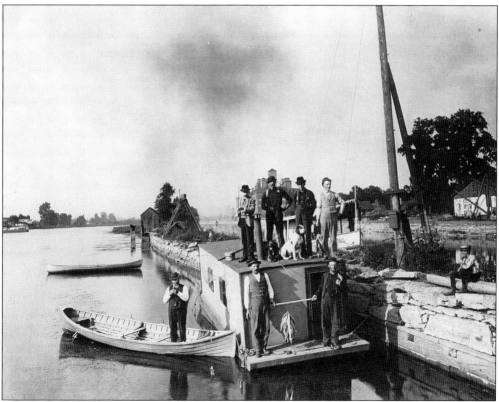

Waterways historically have been not only the source of life and commerce, but also the basis of recreation. As with most American cities, Buffalo devoted most of its waterfront to commercial and industrial activities upon which the city depended, grew, and prospered. But Buffalo residents managed to find a niche here and there. In the 1890s, these men aboard a makeshift houseboat anchored in the Niagara River savor a clearly profitable day of fishing.

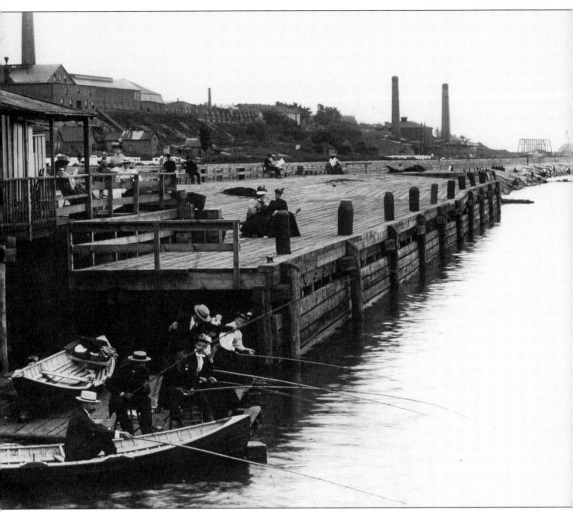

Fishing engaged many people of all backgrounds. This 1898 group of well-dressed folks enjoyed the pleasures of fishing in the Niagara River at the foot of Albany Street just north of Centennial Park. The Massachusetts Avenue water pumping station is visible in the background. It was here that tainted water from the adjoining intake on the Niagara began a wide-scale cholera epidemic in 1902 spawned by the river's serious pollution. Although the 1916 Col. Ward Pumping Station and its purification systems did a great deal to improve the city's health standards, there was no immediate improvement in the quality of the river from which these citizens' fish would come.

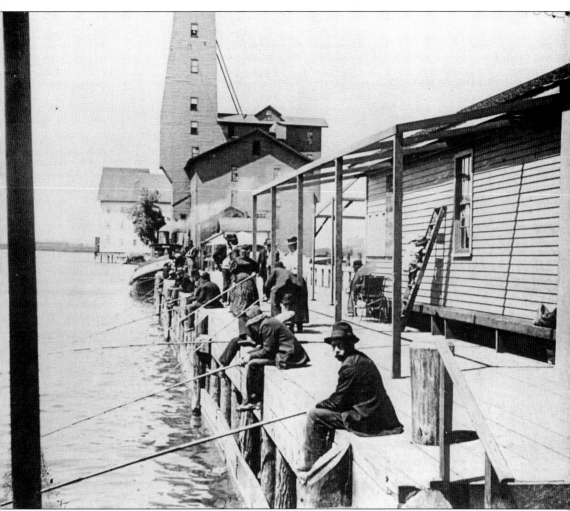

The people gathered here were fishing from the Excursion Boat Dock just south of the Frontier Mill on Squaw Island in 1901 before the dock and mill burned. At the end of the nineteenth century, Buffalo citizens could count on a bountiful supply of many different types of fish in the lake and Niagara River to fill their larders. Perch, blue and yellow pike, bass, some sturgeon, and muskellunge ("muskies") were readily available to the patient angler. Even at this early stage, the Buffalo River was already too polluted to be safe; a slow-moving river, it carried raw sewage and industrial wastes and was responsible for spewing that toxic mess into the lake and Niagara River as well. Still, the Niagara was faster, deeper, and less dangerous for the most part and was the fishing ground of choice due to its relative cleanliness.

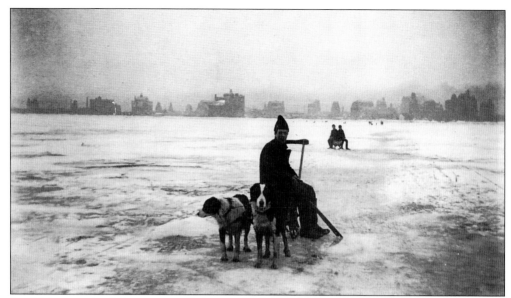

Ice fishing sustained the squatters living on the Breakwall. The men hitched up their dog sleds at dawn and fished all day long with no protection from the elements. They returned at dusk with fish they intended for use at home or, if there were enough, that they sold by the pound to fish company brokers waiting on the shore.

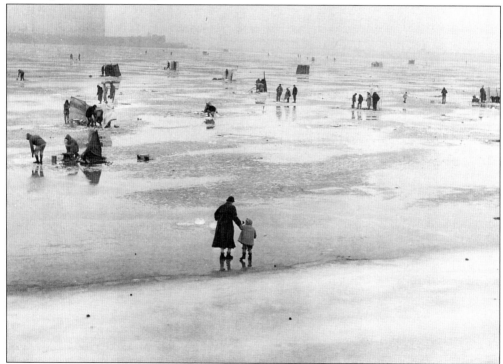

By the 1950s the area now known as the Small Boat Harbor became the prime ice fishing spot. After 1928, the Saskatchewan Pool Elevator, visible in the background, provided some measure of shelter for hardy souls trying to fish in this exposed area south of the Buffalo River. Its relative safety is clear from the woman and child making their way onto the ice.

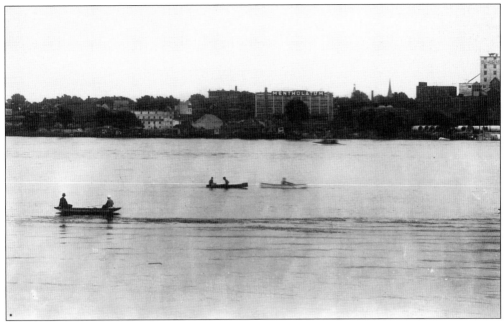

In the 1920s canoes and rowboats abounded among ordinary folks. Some are seen here cruising gently off Niagara Avenue on the west side just south of Forest Avenue. The opening of the Black Rock Canal around the time of World War I calmed a long section of the fierce Niagara and allowed people finally to enjoy the magnificent river safely.

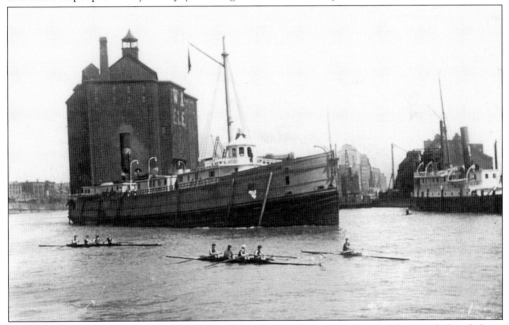

Scullers share space with Buffalo's largest ship, the *Arabia*. The Watson Elevator behind them provided another entertainment; foolhardy swimmers jumped from its tower into the shallow river below. Unfortunately, many died. In 1897 "Akron Jack" was killed; in 1899 "Chicago Red" got stuck in the mud and drowned; and in 1905 the skeleton of a woman was found there also. "Toronto Red," however, survived his plunge before the elevator burned in 1907.

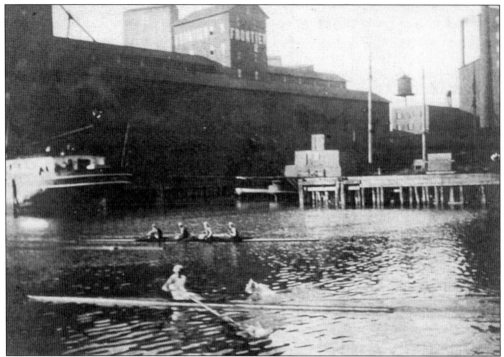

There were two early rowing clubs in Buffalo: the Celtic and the Mutual. The Celtic was all-Irish; the Mutual was inter-ethnic. The latter had its boathouse on the Buffalo River where the Standard Elevator later was built. The single sculler in front of the Frontier Elevator is Mat Burns of the Celtic Club.

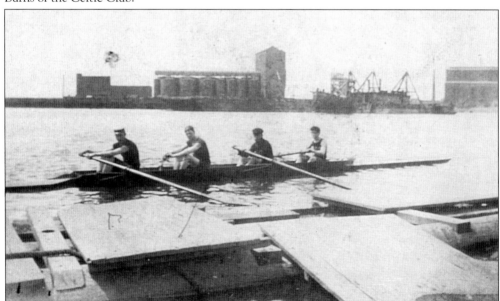

Buffalo's four-man sculls raced competitively as far away as St. Catherines, Ontario; New York City; and Newark, New Jersey. These Celtic Club four-man scullers on the Buffalo River in front of the Electric Elevator about 1905 were Edward Drury, Frank McCarthy, Paddy Murphy, and Jude O'Reagan.

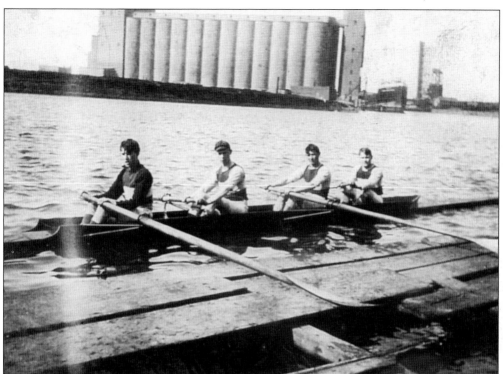

Another four-man team from the Mutual Club practiced near the Mutual Clubhouse on the Buffalo River in 1906. They are in front of the American Malting Elevator. The team consists of M.J. Daley (bow), William Bourghardt (second from left), John Kennedy (second from right), and Mike Daly (stern).

James Cotter was another member of the Mutual Club who specialized in the single scull. He's seen here on the Buffalo River just upstream from the Mutual boathouse practicing in front of the new Perot Malting Elevator about 1907–1908.

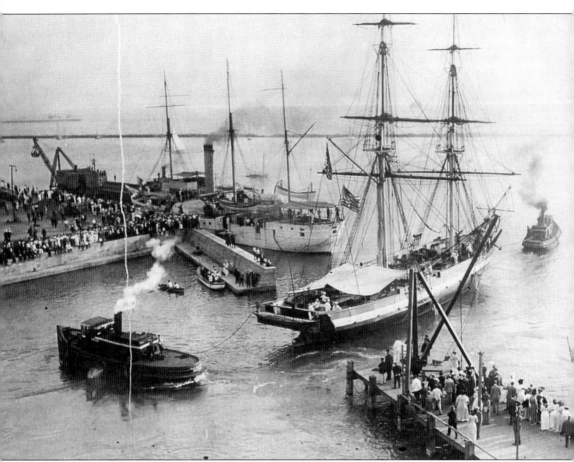

This is a view of the *Wolverine* towing the reconstructed brig *Niagara* out of Buffalo Harbor after the 1913 centennial celebration of Commodore Oliver Perry's Lake Erie victory over the British in the War of 1812. The *Niagara* was not originally Perry's flagship, but survived the battle at Put-in-Bay where his brig, *Lawrence*, did not. Perry then commandeered the *Niagara* and defeated the British fleet. The *Niagara* was reconstructed in 1903 in preparation for the centennial celebration. The *Wolverine*, formerly the *Michigan*, was the first structural iron ship in America, built in Pittsburgh in 1843. The *Niagara* survives today, but the *Wolverine* was scrapped in 1949. The 1913 centennial celebration drew large crowds eager to capture a moment of historical glory; Buffalo, like Erie, Pennsylvania, had played an important role in the War of 1812, and the *Niagara* was a cheerful reminder of that heroic epoch.

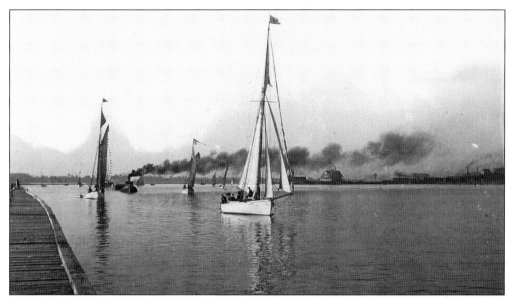

This is a scene from the Buffalo Yacht Club's "Ladies' Day" race on the Niagara River in 1903. Founded as an elite gentlemen's sailing association, the club admitted ladies for special events, such as this, but not as members. The 50-foot cutter *Merle*, yacht club commander George W. Maytham's flagship, is shown here leading the fleet in the squadron run. The yacht club is visible in the background.

Commander George A. Montgomery of the Buffalo Canoe Club is shown inside the breakwall of the Outer Harbor with his yacht, *Lucinda*, in 1905. At this time there were three sailing clubs that catered to Buffalo's prosperous elites: the yacht club, the canoe club, and the new Buffalo Launch Club. Boats were not readily affordable until the era of fiberglass, and boating remained an upper-class luxury.

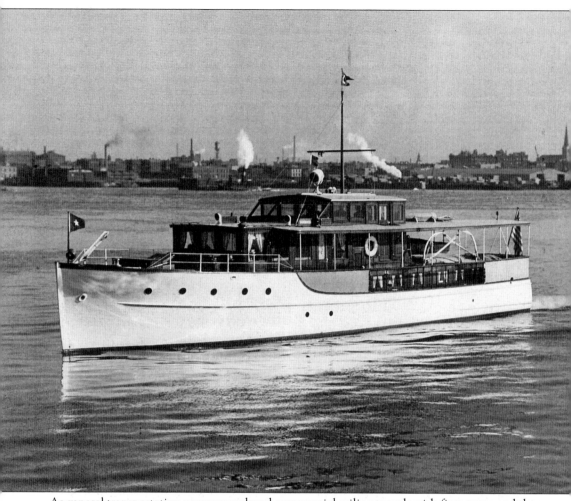

As general transportation progress replaced commercial sailing vessels with first steam and then diesel-powered crafts, pleasure boats moved away from sails and toward motorized forms. By 1936 when this photograph was taken, elegant and expensive powerboats, such as Charles A. Criqui's *Silverheels*, were becoming increasingly popular among those who could afford them. Criqui was one of Buffalo's leading manufacturers of marine engines, and his interest in this type of boat was personal as well as professional. The Buffalo Launch Club was oriented to these new mechanized craft rather than to the more traditional sailing vessels, and it proved quite popular with the adventurous among Buffalo's elite.

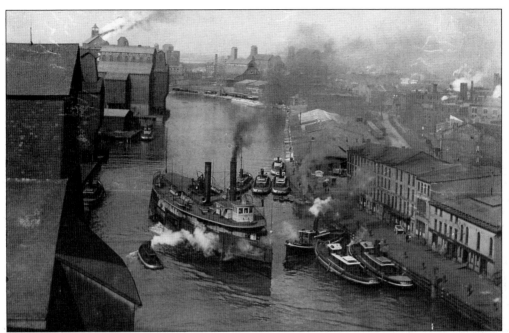

For ordinary Buffalo citizens, a day's sailing generally involved commercial and not private craft. For over a century Buffalo was serviced by cruise ships offering both overnight, long-distance transportation and day trips to Canada or other parts of the American Lake Erie shore. The iron-hulled *State of Ohio*, built in 1880, began passenger service in 1893 from the foot of Main Street to Cleveland, Ohio.

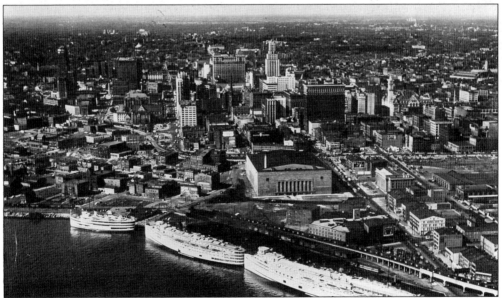

Long-distance passenger cruise service was offered to Buffalo as late as 1969. This 1940s aerial view shows the day-excursion vessel *Canadiana* (left) with two large overnight carriers. In the center is one of the Chicago, Duluth & Georgian Bay cruise ships, and on the right is the *Greater Detroit* of the Detroit & Cleveland Navigation Co. The ships' sheer size indicates the extent of demand that endured after World War II.

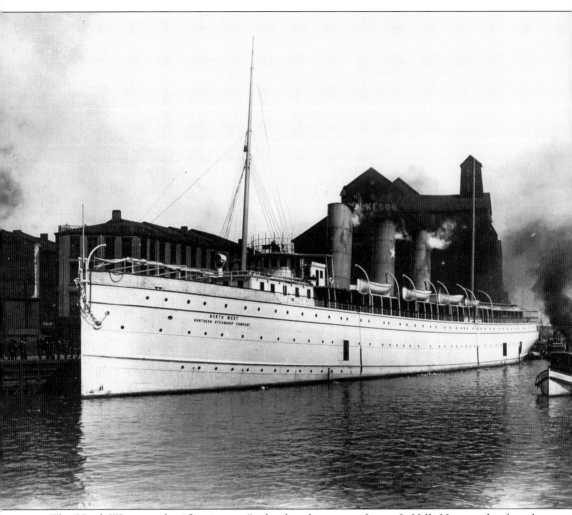

The *North West* was the "floating toy" of railroad magnate James J. Hill. He was the founder of the Great Northern Railroad, the Northern Steamship Line, and the Great Northern Elevator, his grain empire outpost in Buffalo. The *North West*, shown here docked at the foot of Main Street near the Wilkeson grain elevator, was "one of the most palatial steamers on the Great Lakes" according to contemporary observers. Hill, a multimillionaire, used the vessel occasionally for private sailing parties, but both the *North West* and her sister ship, the *North Land*, more frequently carried paying passenger traffic between Buffalo and Chicago or Duluth, Minnesota. Built in Cleveland in 1894, the *North West's* career ended when it burned at its Buffalo dock in 1911.

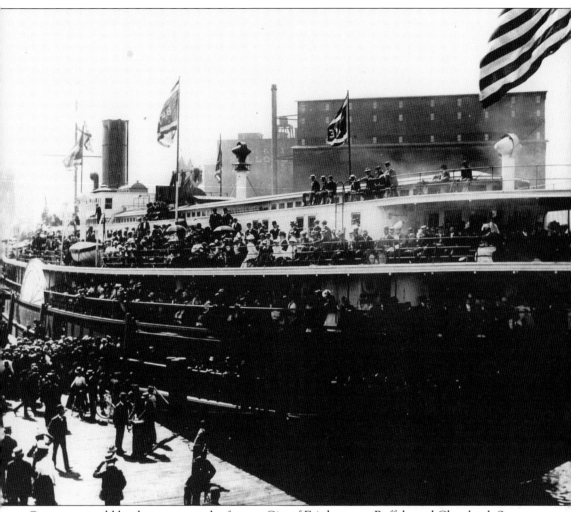

Customers could book passage on the famous *City of Erie* between Buffalo and Cleveland. Seen here at the Michigan Avenue docks, she was known as the Speed Queen of the Lakes. The *City of Erie*, owned by the Cleveland & Buffalo Transit Co., was the victor in a great race staged on June 4, 1901. From 6 miles outside Cleveland, Ohio, to 10 miles off Presque Isle at Erie, Pennsylvania, the *City of Erie* eluded the *Tashmoo* of Detroit's famed White Star Line. The *City of Erie's* time for this 94-mile competition was 4 hours, 19 minutes, and 9 seconds—just 45 seconds faster than the *Tashmoo* but enough to solidify the *City of Erie's* renown. The group boarding here was on a day excursion which the ship offered on Sundays and July 4th. This expedition was to Dunkirk, 40 miles south of Buffalo, and was only 50¢ for the round trip. The vessel was reputedly a "floating palace" and thus put a taste of luxury within reach of Buffalo's working population.

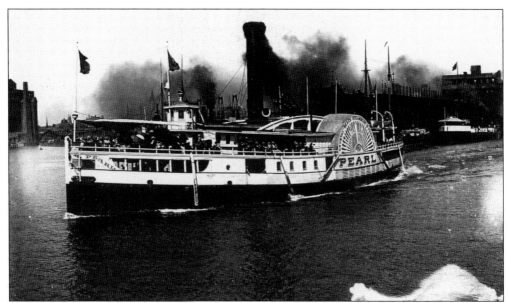

The *Pearl* was built in Detroit in 1875 and was chartered in the 1890s for day excursions between Buffalo and the popular Crystal Beach amusement park in Ontario. The *Pearl* ceased operating in 1900. By 1908 many of the smaller boats were replaced by two much larger vessels, the *Americana* (1908) and the *Canadiana* (1910), which soon dominated the Canadian excursion business.

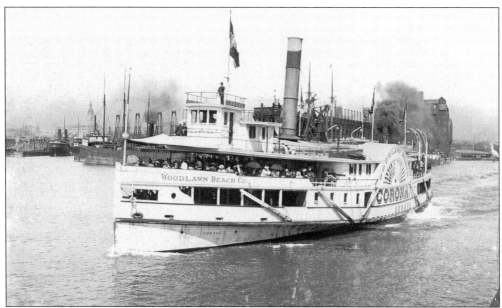

Regular excursion ferries to sites near Buffalo such as Woodlawn Beach, just south of Lackawanna, were also popular. The *Corona*, built in Wisconsin in 1870, plied the waters of Lake Erie, taking travelers to Woodlawn, one of the area's few accessible swimming spots. Before the automobile became nearly universal, reaching recreational beaches would have been almost impossible without ferry services.

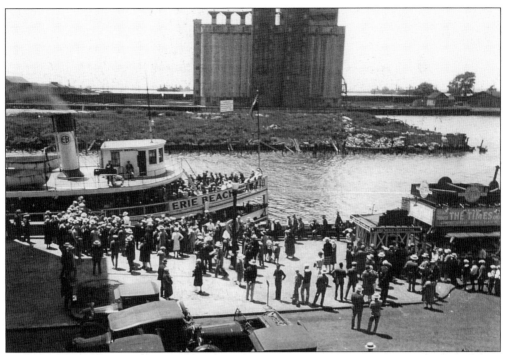

Numerous docks supported passenger and freight traffic. The dock pictured here in 1921 was at the foot of Main Street across the City Ship Canal from the Connecting Terminal Elevator. It was a departure point for the popular Erie Beach boats to Ontario; this service began in 1819 and lasted until 1951. The biggest demand for this service was during the July Derby Days at the Ft. Erie racetrack.

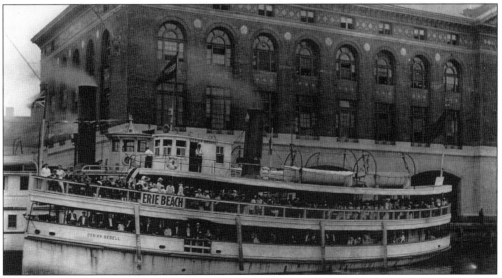

The *Ossian Bedell* became an important Erie Beach vessel. It is shown here in the 1920s with a full passenger complement sailing past the Delaware, Lackawanna & Western Railroad passenger terminal. The *Ossian Bedell* began its career as a ferry carrying passengers between the Squaw Island Excursion Boat Dock at the foot of Ferry Street on the Niagara River and Bedell House, a popular inn on Grand Island.

The demand for inexpensive yet elegant recreational opportunities such as lake cruises was exploding. In 1912 the dock at the foot of Main Street was "one of the busiest spots in Buffalo"; in the summer "10,000 people an hour leave Buffalo for the Play Spots." The two unidentified women awaiting the *Americana*'s departure for Crystal Beach were typical of consumers eager for new adventures.

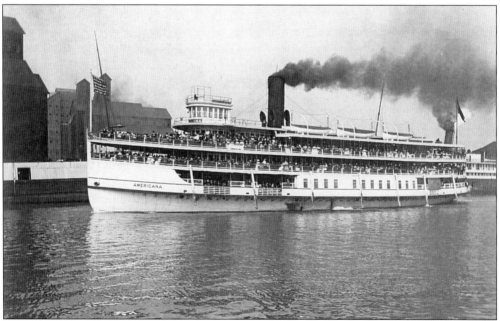

It was the *Americana* that began the most widely-remembered excursion-boat era in Buffalo. She and her sister ship, the *Canadiana*, took generations of Buffalo residents to Crystal Beach on popular day trips. The ships were considered quite luxurious but were eminently affordable, and memories of Crystal Beach cruises still remain. The *Americana* retired after the Peace Bridge opening in 1927 reduced demand, but the *Canadiana* operated through the mid-1950s.

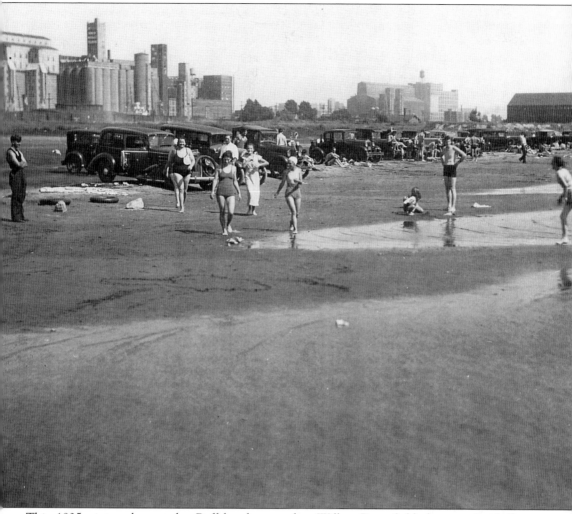

This 1935 picture by popular Buffalo photographer Wilbur Porterfield shows a decidedly unfamiliar scene—swimmers at a beach on Lake Erie. Very few portions of the lake had natural beaches, and the city's economic development put commercial and industrial uses of the waterfront ahead of the purely recreational. Rivers were always unsuitable for swimming due either to dangerous currents or pollution. The people seen here enjoying the water are at Times Beach across from the foot of Main Street. The beach was open only during the summer of 1935 before the department of health closed it again due to pollution from sewage and industrial toxins. Times Beach remains dangerously polluted without extensive remediation, and contemporary Buffalo residents can only hope that as jobs are lost from deindustrialization, waterfront reclamation perhaps may at least provide opportunities for enjoyment of the natural beauty Buffalo's waterways might finally offer.

Acknowledgments

The authors would first like to thank Dr. William H. Siener, executive director of the Buffalo & Erie County Historical Society, who made his institution's photographic holdings available to us. Without his generous cooperation, producing this book would have been impossible.

Because images of Buffalo's waterfront may be found throughout multiple BECHS collections, it is always advisable to consult with the knowledgeable staff in the library when attempting to locate pictures. We particularly appreciate the patience and enthusiasm for this project shown by BECHS Director of Library and Archives Mary F. Bell, Associate Librarian Pat Virgil, Assistant Librarian Cathy Mason, and Library Assistant Yvonne Foote.

Thanks are also due to Willard B. Dittmar, executive director of the Historical Society of the Tonawnadas, for permitting us to make use of the images on pages 49 and 71 (bottom), whose originals are in their collections.

The published works of other Buffalo waterfront historians, past and present, were an invaluable resource. While a formal bibliography would rival this book in length, we would particularly like to acknowledge our debt to Henry H. Baxter, Eric Heyl, Richard Garrity, Michael N. Vogel, Edward J. Patton, Paul F. Redding, and Mark Maio.

Finally we are grateful to Sarah Maineri and Lisa Thompson at Arcadia Publishing, who have facilitated the inception of this project and helped shepherd it through to completion.